Crime, Corruption & Politics in Hull

Crime, Corruption & Politics in Hull

The Rise and Fall of Boss Smith's Old Ring

John Galluzzo

THE
History
PRESS

Published by The History Press
Charleston, SC 29403
www.historypress.net

Cover image: Crossing the Hull Police usually meant a night in the town lockup at the end
of the nineteenth century.

All images courtesy of the Hull Historical Society unless otherwise noted.

First published 2007

Manufactured in the United States

ISBN 978.1.59629.126.3

Library of Congress CIP data applied for.

Dedicated to Joe Boudreau, friend, fellow lover of Boston Harbor history and chaser down of goals and dreams.

"As Hull goes, so goes the State."—old Hull political motto

"If that be the case, then God Save the Commonwealth."
—Boston's response

Contents

Acknowledgements

As with every book I have written on the town of Hull, my first thanks must be extended wholeheartedly to Susan Ovans and Roger Jackson of the Hull Times. It's with them that my writing career truly was born and brought up, and is today going through its teen years. I'm sorry that I don't spend as much time at home as I used to, but am very glad to know that my room is still there should I pop in from time to time.

The idea for this book was generated to be an extension of the work of William M. "Doc" Bergan. The doctor got the ball rolling, and I'm just trying to keep that momentum going forward. It took real guts to do what Doc did. While the characters in this book are all historic figures to me, to Doc they were contemporaries. So here's a thanks to Doc Bergan for introducing so many of us to the colorful political past of the town of Hull.

Many of the chapters in this book have to do with two main characters, Floretta Vining and John Smith. Both live today in the microfilm rolls of the Hull Beacon at the Hull Public Library. Library director Dan Johnson and the staff, especially the recently retired Ann Bradford, have been eternally helpful.

So many other friends have played a part in making chapters of this book come to life: Richard Cleverly and Jim Gillis, our town historians; Chris Haraden, a fellow 1988 Hull High School graduate and Seinfeld nut with whom I share a common passion for local history; the directors and officers of the Fort Revere Park and Preservation Society, including Regina Burke, Rick Shaner, Janet Jordan, Graeme Marsden, Fred Hills, Peter Seitz, Sarah O'Loughlin, Susan Oberg, Harvey Jacobvitz and Joe Beazley; Matt Tobin, the Massachusetts Department of Conservation and Recreation's best-kept secret; Town Clerk Janet Bennett; Don Ritz and the Hull Historic District Commission; Town Counsel Jim Lampke and once and again Town Manager Phil Lemnios; the staff of the Hull Lifesaving Museum; Sue Fleck, for her family's perspective on the old days

in Hull; the members of the Committee for the Preservation of Hull's History, most of whom are named above, but others of whom include Myron Klayman (of Paragon Park fame), Midge Lawlor and the late Brison Shipley; Herb Skellett of Quincy, whose memories of Hull during the days of the Old Ring form the last chapter; and all those historians, living and gone, who have done their part to preserve the history of Hull. Thanks to everybody who's ever commented on a story, given an idea for a new one or joined me on a walk through Hull's past.

My family continues to support my dream of researching and writing history, so to my father, Bob, mother, Marylou, sister, Julie, brother, Officer Nick, and sister-in-law, Kerri, thank you.

Two special educators, R. Dean Ware and the late Franklin Wickwire, pointed me down the right path while I studied history at the University of Massachusetts at Amherst, and a special group of friends who go all the way back to that time, David and Kathy (and now my godson Matthew) Dean and Jay and Leah (and now little Harry) Kennan, still make me smile to this day.

My wife Michelle has finally gotten used to the fact that I write instead of watch TV at night. Thank you for letting me follow my dreams, sweetie. Thanks as well to my parents-in-law, Vito and Sandi Degni, for pulling me away from the computer from time to time to enjoy a family meal.

And no matter what, whenever I write about Hull, I do so thinking about my friend George Kerr. Thanks for your crazy e-mails, Papa G.

If I've missed anyone, it's my fault. If there are any errors or omissions in this book, point the blame directly at me.

Introduction

I'd like to think that with the publication of this book, Doc Bergan, wherever he may be, is cracking a smile. Of course, if that truly is the case, it means that Boss Smith is gritting his teeth and shaking his fist from above.

William M. "Doc" Bergan published Old Nantasket in 1968, exposing more than most of the people of Hull wanted to really know about their town. In its 150 or so pages one can find evidence of and, indeed, confessions about rigged elections that dictated the future of our little stretch of sand. The book tells all about crooked cops, sleazy politics and the people who both benefited and suffered from their existence. The good doctor, a dentist by trade, also documented the important hotel era here in Hull, the early years of Paragon Park and reminded us about personalities from the past that we had otherwise forgotten. His book is a treasure of which every Hull family should own a piece.

"Boss" John Smith, on the other hand, left no memoirs, a fact that in itself makes local historians furrow their brows and sigh. If any character from Hull history should have kept a running journal of his life's experiences, it's John Smith. The Boss, however, left more than enough evidence lying around—in town reports, newspaper columns, etc.—to tell his story quite thoroughly. He was the biggest fish in, as Massachusetts communities go, the smallest pond, and he controlled his fiefdom in ways that made big-time city bosses either envious or angry.

But Smith left Hull much more than an interesting political past. One of the most important facets of his legacy may be the fact that he did all he could to fuel dislike between the people of Hingham and Cohasset and those of Hull, all to suit his own political needs and desires. Although he did not start the rivalries between the communities, the vestiges of which can be traced to the 1640s, through his political shenanigans in regional elections he fostered an inherent distrust of Hullonians in the eyes of the people of the neighboring towns.

Smith's Citizens' Association, the Republican Town Committee or, colloquially, the "Old Ring," controlled local politics down to its very roots. One could not even run for library trustee without the approval of the Boss.

The story that follows is a mostly male soap opera, with storylines akin to those found on professional wrestling broadcasts. As most of the tale unfolds in a time when women could not vote, it is almost exclusively a male story, with appearances by the occasional female, including the ultimate occasional female, Hull Beacon editor Floretta Vining. There are definite sides of good and evil in the Old Ring story, yet one never knows who will jump from one side to the other. Just when you think you know the players, suddenly there's a swerve, an unexpected twist in the storyline that sends the researcher and reader for a loop. Best friends become worst enemies, and the town of Hull pays the price as their war rages out of control.

As far as we know, we've just scratched the surface of the Boss Smith tale. Who knows just how many backdoor deals took money from the town's pockets and poured it into his? Research continues, of course, but for now, I invite you to take a second look at a four-and-a-half-decade period in Hull history when one man's influence shaped our community. Let's return to Old Nantasket.

Beneath the Gilded Edge

Whether you choose to believe it or not, Nantasket Beach once shone out nationwide as one of the most affluent and elegant summer resorts in America. A ride on the steamboat line through the harbor islands or a casual trip on the Nantasket Beach Rail Road's electrified line escorted visitors to the magnificent hotels on the beach, the Hotel Nantasket, the Fairhaven, the Hotel Tivoli and others. The Atlantic House sat atop Atlantic Hill, furnished with a kitchen large enough to "accommodate chefs from four different countries—Germany, France, Italy, and China—each trained to the letter to prepare the delicacies of his native land," according to Doc Bergan's Old Nantasket. Enrico Caruso twice wowed crowds there with his operatic performances, crowds that sometimes included dignitaries such as French actress "Divine" Sarah Bernhardt and President William McKinley. The 360-room Rockland House could boast of an easily as impressive list of visitors, starting with President Grover Cleveland and New York Assemblyman Alfred E. Smith.

Anything the traveler desired could be found on the beach: space to play lawn tennis or golf, bicycle and bathing suit rentals or clam chowders and coot stews. Electric light shows and fireworks displays lit up the summer night sky, and daily band concerts filled the air with the serenading sounds of strings and the triumphant tooting of trumpets.

Yet somewhere around the turn of the century, the moneyed classes began to sidle away from Nantasket Beach for one reason or another. The invention of the car definitely contributed to the downfall of the summer community, as travelers no longer found themselves bound to steamboat trails and railroad lines, but could visit any destination that could be reached by roadway.

Underneath the layers of diamonds and gold, of velvet and lace, a world of uncontrolled crime ruled the beach, and it stretched from the lowliest pickpocket all the way up to town hall.

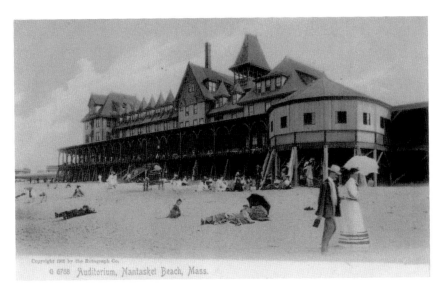

Copyright 1903 by the Rotograph Co.

G 6768 Auditorium, Nantasket Beach, Mass.

When Dr. Edward Bates wanted to exact a bit of revenge for a friend, he walked into the auditorium on Nantasket Beach and landed "one good blow."

Turn-of-the-century crimes in Hull ranged from the petty to the devious to the incomprehensible. Just before 9:00 p.m. on Tuesday August 30, 1897, Dr. Edward Bates strolled into the office of Police Chief John Mitchell and asked to find out what the fine would be for an assault. When the chief stated that it would depend on the nature of the attack, Bates replied, "Oh, well, one good blow." After the chief gave an answer of five to ten dollars, the doctor thanked him and walked out of the building. Understandably suspicious, Mitchell detailed two of his men to follow Bates and watch him.

The doctor walked directly to the auditorium on the beach, where Conductor C.H. Thompson and his Myles Standish Band were concluding their concert. As the conductor stepped off the stage, Bates rushed him and threw "one good blow" into his face. The officers immediately arrested him and brought him back to the station. In his cell, Bates told the story of how Conductor Thompson had insulted a singer friend of his, Miss Addie Norwood, and that he had traveled all the way from Cincinnati to throw the punch. At his arraignment the next morning, he cheerily paid his ten-dollar fine and returned home to Ohio.

Pickpockets abounded at the train terminals and steamboat wharves. The Quincy Patriot Ledger of Monday, July 19, 1897, told the story of one poor soul who came to the beach for the clean ocean breezes, but instead got cleaned out himself. "The facts are these: About six o'clock, the unfortunate gentleman went

to the station to purchase a [train] ticket to East Weymouth…On purchasing his ticket with some change he had in his vest pocket, he moved back and discovered at once before leaving the station that his wallet was gone." When asked for the whereabouts of an officer, the ticket seller told the hapless gentleman that it would be of no use to complain, as upward of twenty wallets got pinched in the station each day.

The barkeepers at the local hotels learned quickly just whom they had to pay off in order to sell liquor after hours and on Sundays. And the bars could be rough spots to visit as well. Joe Lannon of the Fairhaven, who later bought the Boston Red Sox, boasted that he hired his waiters based on their fighting ability. The bartenders of Pogie's Saloon on the veranda of the Rockland Café each carried a loaded revolver, while another hung on the wall behind the register. The Hull Police would raid one site, such as a house near Whitehead, to arrest five men playing cards on a Sunday (as reported in the Hull Beacon, June 19, 1897), but would keep bars open until four in the morning to accommodate their Policemen's Ball.

Houses of ill repute, with comically appropriate names, could be found on any street near the beach. The proprietresses of the Riding Academy, the Pussy Willow, the Ginger Bread and the Cuckoo's Nest all learned how to play the game that the bartenders played, paying off the police and selectmen to remain in operation.

The construction of Paragon Park in 1905 brought large crowds to Hull, and the potential for even more crime than was already taking place on the beach.

In fact, Boss John Smith and his cohorts held complete control over the town. According to the Boston Traveler of August 21, 1897,

> *They own everything and everybody. They sell licenses where they can, and they wink at illegal liquor selling whenever the wink is paid for... They exact a weekly stipend from every "fakir" on the beach. They permit their policemen to filch from the pockets of their prisoners, which they filch from the pockets of the taxpayer...It is an old saying among the old-fashioned voters of the state, "as Hull goes so goes the state." If that is to be the case in the future we may indeed say "God save the Commonwealth of Massachusetts."*

With all of the shenanigans that went on at Nantasket Beach, it comes as no surprise that Hull lost its position as summer home to the elite. As the decades following the turn of the century proceeded, Nantasket's allure diminished, no matter how hard Floretta Vining fought to stem the tide of outgoing vessels. Bergan, who saw the change as a conscious decision by Boss Smith and his cronies, summed up the future in one sentence: "The choice was caviar or hot dog, and hot dog got the nod."

The Golden Mile

The town of Hull has always marched to the beat of its own political drum.

In March of 1774, as the cities and towns of Massachusetts rallied behind the cause of freedom from taxation without representation on the floor of the British Parliament in the wake of the December 1773 Boston Tea Party, Hull chose its own path. As citizens of a remote, ill-populated and difficult to reach site in an otherwise growing colony, the townsfolk in Hull realized the value of having supplies on hand, never knowing when the weather might cut them off from the rest of Massachusetts. Therefore they decided to keep their tea and not burn it or throw it in the ocean, as so many communities had chosen to do. Besides, they reasoned, their quarrel was not with the tea per se, it was with the imposed duty. They resolved that once Parliament repealed the tax, they would, in matters of trade, "on equal terms, in (tea) as in all other articles, give the preference to England, whose true interest we have always considered our own," as reported in the Boston Gazette on April 4, 1774.

Just more than fifty years after an unsuccessful attempt by the town to secede from the United States in 1786, writer John Hayward had nothing but praise for the smooth efficiency of Hull's political processes. He wrote in the New England Gazetteer in 1839, "Hull is remarkable for the unanimity which always prevails among its inhabitants in their deliberative assemblies, and for a spirit of compromise manifest on all occasions in their selection of public servants."

Eight years later, Hayward again wrote of Hull in glowing terms, this time in A Gazetteer of Massachusetts. "Hull is probably the most independent republic in the world; it sustains itself on its own capital, which is constantly multiplying. In its selection of rulers, it is united almost to a man; and few towns in the Commonwealth, of its political importance, are more eloquently represented on the floor of the legislature." These words came just three years after Hull earned its first true political

Until 1899, if you told friends you were headed for Nantasket Beach, they might have looked at you with raised eyebrows.

slogan. After hotel owner, lifesaver and all-around entrepreneur Moses Binney Tower rode to Boston to cast the town's vote for the election of Governor Marcus Morton in 1844 (an election decided by one vote, and the last to arrive being Hull's), the town proudly began to boast that "As Hull goes, so goes the state."

Yet just fifty years later, Hull changed forever. The post–Civil War conversion from a fishing and farming community to a wonderland of amusements and fancy hotels ushered in an era of sleazy politics the likes of which the people in Hull had never seen. That change took place as young John Smith, the son of a Prussian immigrant, grew to manhood in Hull Village. As shrewd a politician as ever lived, Smith knew that amongst the hotels, casinos, barrooms and other amusements on Nantasket Beach lurked piles of money just begging to be illicitly taken. With his election to the board of selectmen in 1893, the downfall of Hull began to take shape. "Here in the late nineties was a town government that condoned, encouraged and protected illegal liquor sales, rampant gambling, prostitution, con games and pickpockets, and the State Police was unable to do a thing about it. Hell had really broken loose in Nantasket," wrote Doc Bergan. The overwhelming and complete spirit of cooperation had vanished forever.

Only four years later, the Boston Traveler published the article that would eventually lead to the Metropolitan Park Commission's takeover of Nantasket Beach. In an August 21, 1897 article entitled "Police Own the Beach: Corruption

Flourishes on Nantasket Sands," the writer blasts the town for its unabashed public displays of political favoritism and overall underhandedness.

> *The Hull police had a ball last night in Nantasket dance hall, and thereby hangs a tale.*
>
> *It was a wild and riotous time. There were frequent excursions over the plank walk to the [Hotel] Tivoli, some of them headed by Chief John Mitchell in person, and the bar, which was kept open until 3 o'clock in spite of the so-called police regulations, was generously patronized by Chief Mitchell and his men…Strangers, innocently supposing that a hotel was obliged to serve food and lodging to respectable applicants, were refused admission to every part of the house except the bar…The Hull police have many balls; in fact, each and every member of the force has "balls" without number all day long and far into the night, and good reason why.*
>
> *The town of Hull, which includes Nantasket, is a sort of private corporation. John Smith is the chairman of the Board of Selectman. John is also superintendent of streets, and, by a strange coincidence, John does almost all of the teaming for the town of Hull. John makes out his bills for teaming, which are generous, addresses them to himself, as chairman of the board of selectmen, and O.K.'s them as superintendent of streets. John has a snap and he knows it.*

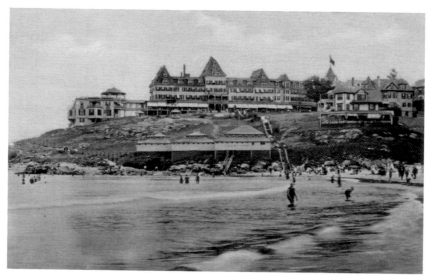

Hotels like the Atlantic House did their best to attract highbrow crowds to Nantasket Beach at the end of the nineteenth century.

The corruption ran even deeper. Hull in the late nineties still held down only a small population—fewer than a thousand year-round residents—and most prominent families had intermarried many times over. Even Joshua James, one of the town's most respected citizens, could be called guilty of nepotism in the most basic sense. When he chose his first crew to man the new Point Allerton Life-Saving Station in 1890, he selected, in order, two sons-in-law, two nephews and a great-nephew. But working with relatives in Hull was hard not to do; when James and the Hull volunteers saved twenty-nine sailors from six vessels during the Great Storm of November 25–26, 1888, twenty-eight of the thirty lifesavers could claim some sort of relation to the captain.

Nevertheless, the Traveler accused Smith of nepotism in its worst form, for he happened to be married to Police Chief John Mitchell's sister. Selectman Alfred A. Galiano also had a brother on the police force. Selectman James Jeffries left his job as ticket agent of the Nantasket Station of the New York, New Haven and Hartford Railroad to somehow support himself financially solely on his selectman's pay. His brother soon ended up with a job as a division superintendent of the New York, New Haven and Hartford.

The article went on to accuse Mitchell of "utter incapacity" in the investigation of evidence in connection with the celebrated and sensationalized Private White case earlier that summer. On the night of June 6, Private Joseph C. White of Battery C, United States Artillery stationed at Fort Warren, hopped on a tug

The coaster and carousel that stood on the beach at Nantasket allowed the local police to have their share of fun, even while on the job.

bound for Hull with a number of other soldiers for an evening of unwinding at the local taverns. After a full night's work of imbibing intoxicating liquors, the group headed back to the Hull Yacht Club pier to disembark on the same tug. Nearly at the island, the soldiers looked about themselves and realized White had not made the return trip.

Thirteen days later, White was found floating at Pemberton, with his throat slit and showing the effects of a strong blow to the head. Begged by White's mother to do something, Mitchell arrested three workmen who were aboard the ironically named tug John Smith. Judge George W. Kelley of the second district court in Abington let the three men go for want of evidence, declaring the death to have been most likely caused by drowning. The Hull Beacon reported on August 21, 1897,

> *It is my judgment that after he was left by (Thomas) McKone (one of the accused) he got up from his seat, there dropping the emblem from his cap, and went toward the tug. He tried to place the ladder so as to board the tug, and in his attempt went overboard with the ladder, his cap falling off on the tug. It was shown that the outer edge of the tug was of iron and sharp. The wound under the chin may have been caused by striking upon this, or upon some projection on the piles of the pier.*

Mitchell accepted the verdict and dropped the investigation, to the outrage of many Hull citizens.

The Traveler continues:

> *Why it was only the other night when one of the Hull policemen singled out one of the many drunken men who staggered forth at late hours from the Hotel Nantasket, followed him up the beach and told him that if he would pay $5, the amount of the fine he would have to pay the next morning in court, he would let him go. He did. These Hull policemen are not so much to blame. They know how far they can go. They watch their superiors and do likewise.*
>
> *They work the drunks; they work the beach fakirs; they work the saloon keepers, who have no licenses and who have, and they even blackmail the women, who frequent the resorts so thickly scattered along the sands. It was one night when I saw a policeman, a big, blonde, moustached [sic] policeman, walk up to a group of girls seated on the veranda in front of the Rockland Cafe, sit down, put his arm about one of them, and, forgetting his duty, gossiped for half an hour. He did not*

know any of the girls. That same night the big black moustached [sic] policeman at the Tivoli spent five, supposed to be very happy minutes on the merry-go-round near by. He made a pretty picture. The girl had her arm around his neck and her head on his shoulder. He was puffing a big cigar and seemed to think he was having a good time. Five Traveler reporters were watching him. Ten minutes later he deliberately left his station in front of the veranda door of the hotel, and followed down the plank walk a young girl who accidentally lifted her dress too high going down the step. These two men are fair samples of the Hull police.

The Traveler admitted to understanding the taking of liberties for political purposes, should they lead to self-advancement, but failed to see how the police profited at all "by committing these nightly holdups, assaults, robberies and crimes of a worse description" that made Nantasket Beach "a place to be shunned by every respectable man after the last boat leaves the pier."

And once the cycle of corruption establishes itself, the Traveler reasoned, it will perpetuate itself ceaselessly.

The riff-raff, the abandoned men and women are the first to flock to a summer resort where they know the police can be bought and sold. There are bathing parties after dark, from which the police studiously keep away, which disgrace civilization. On certain portions of the beach bathing suits are deemed unnecessary. On the more public portions

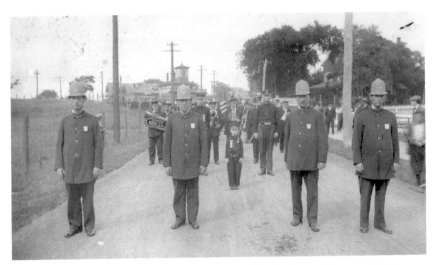

The Hull Police came under fire thanks to an article in the Boston Traveler in 1899.

costumes more scanty than any newspaper dare picture are an every night sight, both among men and women. There is more deviltry and general cussedness at Nantasket Beach today than there is in poor old Coney Island.

So it proved to be absolutely fitting, what with all of the political corruption rampant at the beach, that the writer would refer back to the town's own slogan. "It is an old saying among the old-fashioned voters of the state, 'as goes Hull, so goes the state.' If that is to be the case in the future we may indeed say, 'God save the Commonwealth of Massachusetts.'"

Yet the Traveler did not simply publish the article to expose and denigrate the town government and police force for the shameless bodies that they proved to be. They proposed an end to the wretched state of affairs.

All this violation of the law, all this illegal liquor selling, all this discrimination at hotels, all these holdups of drunks by the police on the beach after dark, all this general deviltry, is winked at, and somebody is paid to wink, or to make others wink. It is time that the citizens of Boston, from whom Nantasket Beach gets its prosperity, should look into this matter. It is time that the Metropolitan Park commission should seek to rescue this beautiful stretch of beach from the thugs and hand it over to the people.

Editor Timothy Harrison of the Hull Beacon called for the people of Hull to take the matter into their own hands.

Who are responsible? is the question invariably asked, and we can only reply that the only persons who have any authority in the matter, that we know of, are the selectmen of Hull...It would seem to be a good idea to hold a mass meeting of all the good citizens of Hull and the summer residents also, and resolve a memorial address to the selectmen. This matter is of vital importance for the preservation of the good name of this resort.

As Hull's citizenry, led by temperance advocate Edward G. Knight and social arbiter Floretta Vining, began to pull together, Chief John L. Mitchell attempted to save face by launching a series of raids at known dives and dens of iniquity on the beach. To the surprise of no one, the raids proved to be mostly unsuccessful, as Mitchell admitted that it seemed most of the proprietors had been tipped off

beforehand. Yet he could not explain where the tips came from, claiming his department to be airtight.

On August 30, 1897, the Traveler made another suggestion for Mitchell, who once compared his own purity of character to Davy Crockett's. "He says he is going to keep up the good work. He could not do better. He might begin right with the police force—discharge all his men and then resign himself. Then much good might be accomplished if his successor was not appointed by Selectman Smith."

Dr. William M. Bergan, once a member of John Smith's inner circle and later its most outspoken opponent, documented the story of the end of town control of Nantasket Beach and the ensuing takeover by the Metropolitan Park Commission in his book Old Nantasket, published in 1968. "The people all over Massachusetts were up in arms [about the current state of affairs]. The resentment ran so high that complaints were lodged with state agencies and with the federal government. Some requests were made to have the town occupied by the armed forces of the United States, but the federal government took the position that it was the state's responsibility."

More than a year later, as the conditions persisted at the beach, Mother Nature ended all debate on the topic. Unleashing the storm of the century on New England on November 26, 1898, forever known as the Portland Gale for the loss of the steamer of that name and the 192 passengers on board, she blasted the buildings at Nantasket Beach to splinters, leaving behind a mind-numbing path of destruction. Floretta Vining, by now the business editor of the Hull Beacon, saw the storm as a blessing in disguise. She wrote in the Hull Beacon on December 3, 1898,

> *Nantasket Beach should now be added to the Metropolitan Park system. Few of the buildings between Kenberma and Atlantic Hill are worth little more than firewood. It would hardly pay to repair them, and doubtless the owners of those that stand intact would be willing to sell. At any rate; "it's an ill wind blows nobody good," and we should not be greatly surprised to see Nantasket Beach greatly improved in appearance by another season. Old Boreas has done what many people have long wanted done—the old shanties, which have long enough mutilated this beautiful locality, removed and better ones put up in their place.*

On February 3, 1899, with the town covered in a heavy blanket of snow, Floretta Vining introduced a bill to the Massachusetts legislature proposing that the park commission take over the entire stretch of Nantasket Beach, from Atlantic Hill to Point Allerton. A separate bill proposing that the town form a board of police

to oversee the force also made its way to the floor, but both went down to defeat. Soon thereafter, Chief of Police Mitchell launched another series of liquor raids. Storming into Vining Villa at Stony Beach, he charged the newspaper editor with illegally serving alcohol without a license. Although later exonerated, Vining learned that she would not win this war against John Smith and his cohorts easily. They obviously would do anything to keep control of the beach.

The public outrage continued. On April 24, 1899, yet another bill reached the floor of the legislature, this one proposing the taking of 5,600 feet along Nantasket Beach and Straits Pond and all adjacent waters. In the end, the pond and its waters were scratched, but on June 2, the measure was passed and enacted into law as Chapter 464, Acts of 1899, including provisions that no liquor be sold on the reservation and no such licenses be sold within 400 feet. The following year, under Chapter 421, Acts of 1900, the park commission took over all the roadways abutting the property taken. Doc Bergan wrote, "Gambling was prohibited, the con men and pickpockets were routed, and the bathers on the beach started to behave like ladies and gentlemen. And so, for that golden mile of beach front, the very heart of Old Nantasket, the honeymoon was over."

Proprietors of amusements and hotels loyal to John Smith and his cronies moved off the reservation and headed for safer spots, such as Nantasket (now Sunset) Point. The Oakland House, at the intersection of Nantasket Avenue and Nantasket Road, moved from the reservation to its current location to mark the

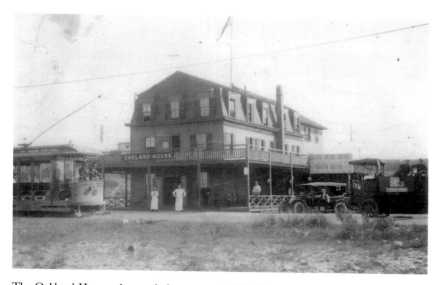

The Oakland House, alternately known as the Mike Burns Inn through the years, sat on Nantasket Beach until the Metropolitan Park Service takeover of the Golden Mile in 1899.

entrance to the new resort area. It stands today as perhaps the last reminder of the hotel era in Hull, when graft and corruption were king.

Although slowed by the encroachment of the Metropolitan Park Commission onto the sands at Nantasket in 1899 and 1900, John Smith knew that the town still had much more to it than just that one mile. Consolidating his forces, he led the formation of the Republican Citizens' Association in 1900. Patterning his "Old Ring" on the political machine of the "Boston Mahatma," Martin Lomasney, Smith spent the next quarter-century fixing elections and exchanging jobs for political favors, publicly humiliating anyone who stood in his way. Between 1900 and 1938, eleven years after Smith's death, the Old Ring never lost a single seat in any election. Only in 1939 did someone finally break through against the Citizens' Association, when Doc Bergan took advantage of a Republican Party rift to take a selectman's seat.

Smith may have won long-term control of the town, but he would never again get his hands on that "golden mile of beach front, the very heart of Old Nantasket."

The state hoped that by taking control of the first Golden Mile of Nantasket Beach, the Metropolitan Park Service could reestablish a family atmosphere upon the sands. Courtesy of the Scituate Historical Society.

The Mayor of Hull

William M. "Doc" Bergan writing in Old Nantasket describes Floretta Vining as "a unique character" who "looked, dressed and acted like Queen Victoria."

In truth, she bore no physical resemblance to the British monarch, least of all facially. And, after her husband passed away, Queen Victoria (who reigned from 1837 to 1901) wore the black of mourning for the remainder of her life. Floretta, with a personality as ostentatious as her name, dressed to suit both. Yet Doc Bergan was definitely right on the third count, for although she was not royalty, Floretta Vining held court once a week for much of her adult life through her editorial column in her syndicate of South Shore newspapers. Born to Alexander and Fanny Vining in 1848 or 1849 (she never revealed her true age), Floretta grew up in her father's hotel, the Mansion House, at the Pemberton end of Hull. Mr. Vining had built a fortune in the wholesale leather business in Boston.

Born and educated in South Scituate (later Norwell), Mr. Vining did not move his family to Hull until 1857, at age forty, but he immediately became active in town affairs. As selectman, he pushed for the idea that the town should have a country road between Hull Village and the Rockland House Hotel at the south end of the beach. After fire destroyed the Mansion House on February 12, 1872, Vining moved his family to Quincy, where he resided until his death in January of 1885.

Floretta, whose mother and sister had already passed away by then, inherited every penny of her father's magnificent fortune. She moved into her "seaside cottage" in Hull in May of that year, and lived there until it mysteriously burned down on March 12, 1890, while she was away in the nation's capital. On May 20 of that year, contractors began work on the construction of her palatial Stony Beach home, Vining Villa. Floretta spent the summer in Europe, returning only when her home had been completed.

Had Floretta Vining had her way, scenes like this one would have been more common on the streets of Hull.

In the late 1890s, Miss Vining (who remained single her entire life) began building her newspaper syndicate. She joined in partnership with local newsman David Porter Mathews in the summer of 1898 to print the Hull Beacon, an eight-page weekly. Although the paper ran local and some national news, it mainly served as a social register for the summer community, "devoting a six column page each week listing the arrivals of the wealthy visitors to the hotels and summer homes," according to Bergan's Old Nantasket.

Floretta used her position as editor to push for social change, becoming a big thorn in the side of John Smith and the Citizens' Association. She so loved the town of her youth that she strove to make it the exclusive summer home to Boston's elite. She moved among the finer social circles of the city from her winter room at the Parker House in Boston, holding titles such as first regent of the John Adams Chapter, Daughters of the American Revolution; vice-president of the Abbott Academy Club; auditor of the New England Women's Press Association; director of the Women's Club-house Corporation; and she was only the second New England woman admitted to New York's Sorosis Club, an extremely exclusive women's guild.

While rubbing elbows with the likes of Boston Mayor Patrick Collins, actress Julia Arthur and good friend Hetty Howland Greene, who at the time easily ranked as the richest woman in America, Floretta would casually mention that

"Nantasket is destined to become the greatest summer resort in the world. The carpings of the disgruntled and the pessimist cannot prevent it," as she wrote in the Hull Beacon on August 31, 1900.

Unfortunately, Hull's year-round populace could not always be counted upon to act in the cultured manner Floretta knew would be needed to attract a higher class of visitor to town. She wrote in the Hull Beacon on August 21, 1903, "The 'greased pig' entertainment should be relegated to the barbaric ages, as it contains no element which can recommend it to people of cultured and refined tastes."

She was always worried about what outsiders would think, and tried to act as the community's moral watchdog. "People sitting on their verandas often get bits of conversation off the bay which had much better be spoken behind closed doors. Few people realize what a conductor of sound water is."

Sometimes, though, she had no better recourse than to just throw her quill pen in the air in disgust. "We have a drum in our midst, and if there is anything to be enjoyed it is a drum used by an eight-year old boy, and with that added to his screaming is certainly pleasant."

And, of course, she lamented the fact that Hull could provide no good help for the summer visitors, as she wrote on July 21, 1903. "This summer has been for all my neighbors the most miserable. Within a month a small family here in this town has had three general housework girls and the fourth became a little sick, went into a fit and died. You can see how pleasant their summer has been made."

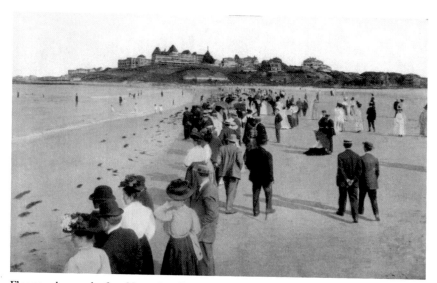

Floretta dreamed of a Nantasket Beach that catered to the rich, famous and, most importantly, well-bred.

Miss Vining did much more than talk about improvements for the town. Described by the editors of the Biographical Review for Plymouth County, 1897 (or rather, by Floretta herself on the form provided for publication with her payment for inclusion) as a "lady of much physical vitality, as well as of superior mental force," she often spoke out at town meeting about her cause du jour: a town dump to prevent the townsfolk from throwing their trash on the beaches, a sidewalk along Gallops Hill, a receiving tomb for the cemetery, etc.

When the town opposed her plan for laying out Spring Street, she went directly to the county government, which ordered the road built. Unhappy with the sporadic and unreliable delivery of mail to Hull, she visited the postmaster general in Washington, D.C., who acquiesced to her demand of twice-daily delivery.

She led the fight for the establishment of the Point Allerton U.S. Life-Saving Service Station, built on her property, just as she had donated land on which to build the Stony Beach Massachusetts Humane Society boathouse. Also interested in the education of the town's youth, she convinced the selectmen to pay $1,000 per year to send Hull students to Hingham High School, a tradition that continued until 1958. In fact, she could be counted upon to stand at the forefront of all of Hull's battles. "A petition is being circulated and largely being signed for the Hingham Water Company to reduce their rates this year in Hull," she informed readers of the Hull Beacon on March 7, 1902.

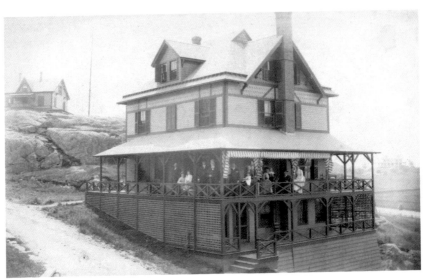

While Floretta Vining found some architecture in town to be dreadful, she delighted in well-kept summer cottages like this one on Atlantic Hill. Courtesy of the Scituate Historical Society.

Floretta also felt very strongly about the aesthetic beauty of Hull's buildings, and did not mind speaking out against what she viewed as inappropriate architecture. "The new laundry looks like a jail," she wrote on March 14, 1902. She would take on all comers, and did not care whom she crossed, as when she wrote on August 29, 1902, "It is sincerely hoped the government water tower will be made a thing of beauty instead of the hideous thing it now promises to be."

As an educated woman of the world, Floretta intently observed the roles women played in society and burned inside for equality and fair treatment. She used her editorial column to instruct young women as to how to better themselves socially, to improve their lives and achieve at least equal status with men. Sometimes, though, she simply went about it the wrong way. "Some girls remind me of Dutch windmills by the awkward swinging of their arms when walking. It is a habit to be corrected if one cares to be graceful and to show a training which is not underbred," she advised in the Hull Beacon on September 4, 1903. She also put all the responsibility for that training squarely on the shoulders of the town's females. "If these young women of Hull have no more respect than to be running around with soldiers who spend most of their time at Surfside, how in the world can they expect the regards of their neighbors?" she wondered on March 28, 1902.

Although she denied having anything to do with its organization, Floretta stood firmly behind the South Shore Society for Protection Against Naughty Lovers. The society met regularly in 1900, keeping note cards on male visitors to the South Shore to inform young women of the area which gentlemen could be trusted in a relationship and which should be classified as wayward two-timers.

Yet, as much as she wanted to believe that every woman could be inherently good and pure of heart, she realized that from time to time a member of the fairer sex could be unchaste and cause problems. She shared such a story in the Hull Beacon of September 25, 1903:

> A pretty stenographer in a man's office is a dangerous thing. I know of a man, a prominent man in Boston's business circles, who lived with his wife 19 years, and never had a word of disagreement, who coolly said one morning, "Mrs. H——, I have decided to divorce you, I like my typewriter better. I will give you so much, you select a lawyer, I have mine, and this thing can be accomplished at once without any publicity."

And she knew that others did more than just stray. "I have far more sympathy for men than I used to. I know men that have to take up the daily paper to know where their wives are," Floretta wrote on June 21, 1901.

Unfortunately for us, her discerning tastes caused her to live by a self-imposed censorship, and we may never know her opinions on some of Hull's seedier—and therefore more interesting—events. She wrote on October 15, 1898, "No, this paper is not a Cesspool of Scandal. We shall try to keep its columns pure and sweet and clean, fit for an angel to read. This paper is for the home. That is why we have not referred to recent sensational events." Although sometimes she just could not help herself, as on October 30, 1903. "A young married woman of this town slapped her husband's face at a party the other evening."

Whether complaining about the paint jobs of boats on the bay, demanding a halt to "golph" on Sundays or threatening to publish the names of girls in town whom she felt were not even trying to live up to her standards, Floretta Vining, the self-proclaimed "Mayor of Hull," always had something to say. And most importantly, she knew exactly where she stood in her community. The Hull Beacon asked on July 25, 1902, "What can be done about that crazy woman who attends to everybody's affairs but her own?"

The Great Hooker Parade

Floretta Vining always knew where to find a party. Spending most of her life with her nose in the air, she nevertheless could sniff out a gathering of revelers better than most. Such was the case when she found herself shopping through the streets of Boston one June day in 1903.

"It was my good luck that is always with me that allowed me to see the procession at its best," she wrote in her July 3, 1903 Hull Beacon editorial, "The Great Hooker Parade as I Saw It." "After doing several errands I made my way to the State House. You had only to possess a red slip or a green one, when you could pass the guards. You were lost up at the State House. Everybody was away down front so I went the way of the crowd. The entire front of the great lawn was entirely covered with seats."

Miss Vining, as she liked to be called, had stumbled into Massachusetts' "State House Hooker Day" and the dedication of the new equestrian statue to one of the state's most accomplished military sons, Major General "Fighting Joe" Hooker.

Hooker's checkered combat career began in the Mexican War of 1848. A West Point graduate from the class of 1837, he set himself down a tarnished path shortly after the war when he testified in a court of inquiry against General Winfield Scott. In 1853, he resigned from the United States Army to farm and sell land in California, but the outbreak of the Civil War in 1861 drew him back east. He sought a commission to fight for the Union, but his condemning words against Scott forced President Abraham Lincoln to pause. Hooker traveled to Virginia to observe the first battle of Bull Run. After the Union loss he sent a letter to the president complaining of mismanagement by the Northern officers and advancing his own claims of tactical knowledge superiority. Lincoln appointed him as a brigadier general of the United States Volunteers on August 3, 1861.

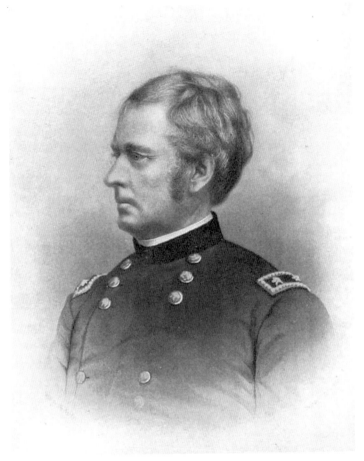

General Joseph Hooker was one of Massachusetts's most beloved heroes of the Civil War. Courtesy of the Scituate Historical Society.

Hooker's temper and alcohol dependency drove him to accept and resign from a number of posts as the war moved along. He saw action with General George McClellan in the peninsula campaign, at Williamsburg, at Seven Pines and Malvern Hill. Lincoln promoted him to major general following Williamsburg, and gave him command of his own corps for the Maryland campaign, where he fought at South Mountain and was wounded early in the day in action at Antietam, some of the bloodiest fighting of the war.

When General Ambrose E. Burnside faltered at the battle of Fredericksburg, Lincoln turned command of the Army of the Potomac over to Hooker. Swearing off alcohol, Hooker focused his thoughts on the defeat of Confederate General Robert E. Lee. His costly hesitancy at Chancellorsville, though, allowed

The Great Hooker Parade

Confederate legend "Stonewall" Jackson to outflank his army as Hooker engaged Lee head-on. He finally lost his nerve when an artillery shell struck the post he was leaning against on the porch of the Chancellor house, his headquarters. He pulled his men from the field and retreated. He resigned his position less than a week before the battle of Gettysburg.

Lincoln then sent Hooker to the west, to the Army of the Cumberland, where again he showed a flair for military strategy when he and his men took the battle of Lookout Mountain. But when he was passed over for a promotion on the death of a fellow general, he again resigned. He finished out the war in the upper Midwest, the relatively quiet Michigan, Indiana, Ohio and Illinois territory.

Hooker, who died on October 31, 1879, left behind a legacy of hard drinking and hard fighting, but will most likely be remembered for the slang term for prostitute that was supposedly derived from his surname. His headquarters were sometimes viewed as part bar, part brothel, and there is no doubt that camp followers stuck close by "Fighting Joe" all throughout the war.

Whatever his problems may have been with the Union army leadership, and although he treated his subordinate junior officers poorly, he had a reputation for taking great care of his men, and it was his men who turned out to celebrate his life that day in June of 1903.

The day had become a general holiday in the city of Boston, as many businesses shut down for the grand parade of sixteen thousand current and former military men, the entire procession led by a detachment from Hull's Fort Revere. "The regulars with Lieut. Starbird of Fort Revere commanding were a delight," said Vining. "Every inch a soldier as they passed the Governor."

Vining had scoped out a perfect seat for the procession and dedication. "I had so many friends there that I sat down and had a nice visit with prominent ladies and gentlemen who live along the South Shore. They gave me fine sandwiches and pastry and moxie." She knew, too, how privileged she was to sit where she was, even if she had a backhanded way of showing it. "Everybody you ever saw in your life around Massachusetts was there on the grandstand, and yet I venture to say there were two hundred vacant chairs right about me. I thought what a shame when all the time women on the common side were fainting from a long anxious wait." In the face of all the fainting, Vining just spread out and enjoyed the show. "I had two chairs to sit in, one for my umbrella, another for my bag and another to put my feet on the rungs. I was so sorry to have such luxury when so many would have enjoyed resting there."

Troops from the U.S. Army and sailors of the U.S. Navy led the parade, followed by Governor John L. Bates and the Massachusetts Volunteer Militia. The men of the Grand Army of the Republic, veterans of the Civil War, fell in

line next, leading a cavalcade of carriages carrying distinguished guests including Lieutenant General Nelson A. Miles, Major General John C. Breckenridge and Major General Joshua Lawrence Chamberlain. Hull's James Lowe, a Civil War veteran, watched with awe as the procession passed by, forgetting to salute when the time came.

Floretta Vining had missed the actual dedication of the statue at nine that morning, when Joseph Hooker Wood, grandnephew of the late general, pulled the cord revealing the work of sculptors Daniel C. French and E.C. Potter. She also missed the speeches of the many gathered dignitaries at Mechanics' Hall later that night, but she had witnessed the most grandiose military spectacle in Boston in many years. And for once, she had nothing but nice things to say.

"I tell you when I was at the boat to see the company from Hingham (Co. K), all real gentlemen, march aboard the boat, I was proud I knew them all and that I knew most of the regulars and the officers, Lieuts. Starbird and Robinson at Fort Revere, especially Starbird, who had led so grandly, the entire procession."

And that was the "Great Hooker Parade" as Floretta Vining saw it.

Massachusetts Governor John L. Bates marched in the Great Hooker Parade.

Floretta Versus the Lepers

Hull Beacon publisher Floretta Vining traveled extensively during her seventy-three years, and while in the newspaper business she made it a point to report back to her little hometown with news from abroad. Whether dining with President and Mrs. Theodore Roosevelt in Washington, D.C., gossiping with the ladies of the Sorosis Club in New York or marveling at the world of tomorrow at the St. Louis Exposition in Missouri, she made sure the readers of her South Shore syndicate of newspapers at least got a taste of what was going on elsewhere in the world.

Vining also made it a point to travel locally. Each year she reported on the towns in her readership and her visits to friends in communities like Weymouth, Norwell, Rockland and Scituate. She kept her finger on the pulse of Massachusetts politics by spending many winters at the Parker House Hotel in Boston, and on several occasions she ventured beyond the borders of the South Shore to spend time among friends on Cape Cod.

Vining fully believed in the development of Cape Cod. Having been born in Hull, she had seen the growth of the town from a hardworking farming and fishing community to a relaxing summer wonderland. At the time of her birth, about 1849, only a couple of small rooming houses operated in the summer season, like the Nantasket House (which stood on the open lot beside the Hull Public Library) and the Sportsman, later to become the Worrick Inn, just north of West's Corner. When Floretta was five, Colonel Nehemiah Ripley opened a small summer hotel at the south end of the beach, calling it the Rockland House. Within a few decades, it would be the largest hotel of its type in the United States. With Cape Cod's miles of shoreline, sandy dunes and rustic charm, Vining, like many others, envisioned the same future for those towns.

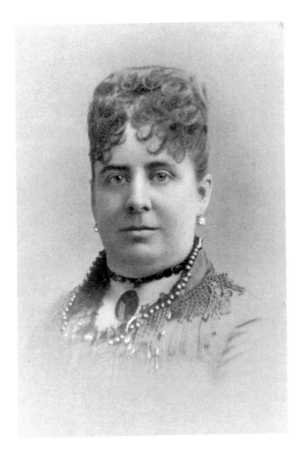

Floretta Vining stood against the development of Penikese Island as a home for the state's lepers.

Early in 1905, though, just as the Cape was being "discovered" by many summer travelers, as the advent of automobile transportation had opened up many hidden pathways until that time inaccessible to alternate modes of transportation, the region stood on the brink of financial disaster, according to Vining. She wrote in her January 13, 1905 Hull Beacon editorial "Cape Cod and the Lepers," "The Massachusetts State Board of Charities has on its hands three lepers in different parts of the state—one at Harwich and two on Gallop's Island. It is evidently their idea to bring them together and they have very recently decided to purchase a tract of land on Cape Cod. By so doing they have incurred the dislike of Cape Codders, collectively and individually."

Leprosy, or Hansen's disease, as it is known today, carried a much more serious social stigma in 1905 than it does now, a century later. Norwegian scientist Dr. Gerhard Armauer Hansen isolated the leprosy bacterium, Mycobacterium leprae, in 1873, and three general forms of the disease became recognizable, ranging from tuberculoid, the mildest, to lepromatous, the most

severe. Although contagious, the disease can only affect about 5 percent of the world's population, as the other 95 percent are immune to it.

Contrary to popular misconception, the body parts of sufferers of Hansen's disease do not simply fall away. The disease mainly affects the extremities, the cooler areas of the body, causing a loss of sensation that leads to unnoticed injuries. Broken bones in the hands and feet that go unobserved lead to mutilations and deformities. Also, through a process called bone absorption, the body consumes its own bone and cartilage in these areas, including the nose, leaving patients with shrunken parts. Lesions may appear on the skin as well.

Today, approximately 12 million people around the world suffer from Hansen's disease, 70 percent occurring in India, Nepal and Myanmar alone. About 110 United States citizens are known to have the disease, with most instances happening in Florida, Louisiana, Texas, California and Texas— tropical climates—and New York.

Louisiana led the charge for treatment of Hansen's disease patients by building a hospital in a tiny hamlet named Carville, eighty miles outside of New Orleans, in 1894. An attempt to open a second hospital in 1901 led to an angry mob torching the chosen building to the ground, instigated by fear of the disease spreading throughout the population. Such was the mentality of the general American population when the Massachusetts Board of Charity began their search for a parcel of land on Cape Cod in late 1904.

"Is the whole of Cape Cod to be ruined for the sake of three alien paupers?" continued Vining. "Now to the prosperity of Cape Cod—this generation has done much for Cape Cod, which never was before so prosperous as today. The State and United States are improving their harbors. Each of the towns have men who have bought up their ancestral homes, improved and remodeled them into things of beauty." She then cited several specific examples of men and women she knew, and what they had done to beautify their region.

The first major step had been taken on December 31, 1904, when state officials purchased the sixty-six-acre Bassett Farm in Brewster as their expected new leprosy hospital. (A gentleman named Franklin Underwood had purchased the farm on December 30 from the Bassetts for $1,500, selling it to the state the next day for $50 more.) The public outcry was so swift and loud that the residents of the Cape—both summer and year-round—called for a public hearing on January 8, 1905, which instantly became the largest public hearing ever held in Boston until that time.

"Now to the industries of Cape Cod," Vining wrote.

Scallops that have each year gained in popularity are found on Cape Cod and in fact it is fast gaining ground as a great industry. Vast

sums of money have been spent within ten years to perfect the cranberry industry, large tracts of land having been laid out, stock companies have been formed and each year has seen new owners, with capital to improve the lands until today Cape Cod stands preeminent as growing the best cranberries in the world and thousands of barrels go to Europe each year, with a steadily increased value. Is all this to be ruined by the indiscretion of a few?

Then, showing the insensitivity of her time and an ignorance of or inability to have faith in the fact that most of the world was immune to the disease, Vining outlined a scenario that displayed her fears and the fears of many Cape Cod residents. "Cape Cod has luscious berries of all kinds, and in summer when men and women are peddling them about the streets and from house to house you will hear your hosts and hostesses asking, 'Did these come from anywhere near the lepers?'" Such mass phobia led to the social casting away of sufferers of the disease at the beginning of the twentieth century.

In the end, Vining cast all the blame onto the state board of charity for ignoring the potential downfall of Cape Cod, calling for their dismissal. "Do away with a board that has no further insight into the welfare of the country. Cape Cod has lived and flourished till today when this proposed stain is cast upon it." She then guided the final sentences of her editorial to the people of the Cape themselves. "Awake and demand your rights and protect your homes from associations such as is proposed. Let the unclean live upon an island. That is the place for them. To get a home is one thing—to protect it is another. Arise, ye men and women of Cape Cod."

Public sentiment became so strong by the summer of 1905 that the state sold the Bassett Farm to the Town of Brewster in June and continued their search for a proper site elsewhere. On July 18, 1905, despite protests from the residents of New Bedford and Fairhaven, the state purchased Penikese Island, one of the

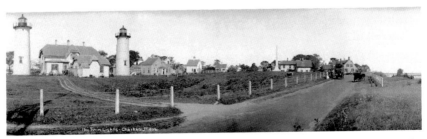

Much like her thoughts on Hull, Floretta Vining saw great potential in towns like Chatham as future summer resorts. Courtesy of the United States Coast Guard.

Floretta Versus the Lepers

Elizabeth Islands off the south coast of Massachusetts, opening the Penikese Island Leper Colony (also known as the Penikese Island Hospital or Leprosarium) in November. Five patients reported when the facility opened. The hospital remained active until 1921, when the remaining patients relocated to a new federal facility in Carville, Louisiana.

Floretta Vining, using the power of the press, contributed to what she saw as a victory for the people of Cape Cod, one that today might be viewed as inhumane and politically insensitive. But Vining was most definitely a product of her age, and one of the rare few to have her own weekly forum from which to throw out her opinion.

HoneyFitz

G rowing up on the wharves of the North End of Boston, with the masts of the sailing vessels of the world as his backdrop, John Francis Fitzgerald loved the ocean. According to one observer and recorded in Francis Russell's The Knave of Boston, "He felt the sea in his bones."

Fitzgerald started out life in a red brick tenement near the Old North Church, a four-story building that seven other families concurrently called home. His family alone constituted a unit of nine.

"Their flat had no bath, no modern gas lighting, but no other family shared the few rooms and there was always food on the table. By the standards of the Irish North End the Fitzgeralds were well off," continued Russell. The father, an Irish immigrant from Wexford, had pulled himself up from the stereotypical role of a simple laborer to become the proprietor of a grocery and liquor store.

"Johnny Fitz," born February 11, 1863, and always small for his age, charmed his way to the top of the Boston political world. As a young man he took charge of many of the social functions held by the priests of the North End's St. Stephen's Church, each time out shaking a new hand or making another acquaintance. As a teen, he learned the art of the big city politician; he would perfect it as an adult.

His mother died while Johnny was attending Boston Latin School, reaching for more than a simple grammar school education; his father passed away after Johnny's first year at Harvard Medical School. Johnny Fitz quickly realized that although two of his brothers were elders, he would have to be the responsible one and take care of the Fitzgerald family. He quit school and got a job at the custom house as a clerk. After three years he resigned and went into business for himself as an insurance salesman in the North End, focusing on fire insurance.

"In those willow years he joined every organization that came his way and made his way to others...He was glib and persuasive in casual talk, he was

noddingly acquainted with almost all the North End families, and he knew every voter by name," wrote Russell. Fitzgerald spoke glowingly and nostalgically at times about the "Dear old North End," so much so that his supporters acquired the nickname "Dearos." Finally, in 1892, he ran for political office, capturing a seat on the Boston Common Council.

Fitzgerald attended every dance, specializing in coaxing wallflowers from their seats and getting them to waltz with him. He kept up on marriages in his district, always sure to send along the most lavish gifts. He paid respects at every wake held for deceased supporters, assuring himself of the votes of their families and friends. He even kept an index card file of the names of all of the people in his district who needed jobs and did his best to see that they found work.

Late in the summer of 1892, Fitzgerald announced his candidacy for the state Senate. Receiving word that he had the backing of Ward Eight's "Mahatma," Martin Lomasney, the original Boston city boss and the man who taught everything he knew to Hull's John Smith (so well did Smith learn, in fact, that Lomasney marveled at the efficiency of the Hull town meetings, finding the system to be superior to his own), the North End Napoleon, as Fitzgerald was called, marched to a near-unanimous election.

Always ready to shake a hand, as here at the Harvard Air Show in 1909 at Squantum, John "HoneyFitz" Fitzgerald spent some beautiful summer days in Hull while at the height of his political career. Courtesy of the Quincy Historical Society.

In 1894, he set his sights on Congress, winning the seat only after a bitterly fought campaign that included every election-night shenanigan possible, when even the dead came back to vote.

During Fitzgerald's first term as congressman, he stood as the only Catholic in the House, and although he gained little reputation or respect while there, his love of Boston Harbor did inspire him to sponsor a bill to purchase the frigate Constitution—then rotting away in Portsmouth, New Hampshire—to reopen the Charlestown Navy Yard and to obtain several million-dollar appropriations for the betterment of the harbor itself.

Fitzgerald sat for three terms in Congress while his brother Henry watched over the North End. When Johnny Fitz returned home, to a house purchased in Concord, he joined three other ward bosses—Smiling Jim Donovan, Joseph J. Corbett and P.J. Kennedy—as the mayor makers of the city of Boston. In 1901 they supported the respectable and incorruptible Patrick N. Collins for the job, a position he easily captured. He would be the last honest mayor, save for one aberration, that the city would see for half a century.

Biding his time while awaiting his crack at city hall, Fitzgerald purchased a run-down newspaper, the Republic, for $500, turning it into a $25,000-a-year Irish social register. He soon left Concord to move to Welles Avenue in Dorchester and, in 1905, upon the death of Collins, decided his time had come.

Fitzgerald set out on the campaign trail to build a "Bigger, Better, Busier Boston," denouncing the ward bosses and their political machines, turning his back on his former allies Lomasney, Kennedy and Donovan and accepting the support of young Democrats like James Michael Curley. He spoke ten times a night on average, moving from ward to ward, reaching his high point the night before the primary with thirty speeches. All the handshaking, all the dances and all the kissed babies served their purposes, as he defeated City Clerk Edward Donovan for the Democratic nomination. From there, Fitzgerald moved on to beat Republican Louis Frothingham and, finally, step into the office of mayor of the city of Boston.

Serving in that capacity from 1906 to 1907, and again from 1910 to 1913, Fitzgerald described his political agenda by saying, "I have not been content merely to fulfill the letter of the duties of the mayor's office, but I have endeavored by every means to make the city better and more prosperous."

He ordered the Boston Fire Department to flush the streets during hot weather, and offered free rides on the ferry for the poor to keep cool at night. He instituted the tradition of having a Christmas tree on Boston Common and opened the Franklin Park Zoo.

"His life is an illustration of the heights to which one can rise who has indomitable pluck," wrote the editors of the State Street Trust Company's Mayors of Boston during his tenure in 1913.

Conversely, Fitzgerald replaced the doctors serving on the board of health with saloonkeepers and created jobs, such as city dermatologist, for his Dearos. Graft ran rampant through his office. Eventually his shady dealings would catch up to him, as his one-time understudy, Curley, running against the North End Napoleon in 1913, threatened to tell the world of his affair with a cigarette girl, Toodles Ryan, from the Ferncroft Inn on the Newburyport Turnpike. Knowing when he had been licked, Fitzgerald pleaded illness and pulled himself out of the race.

After his "retirement" from the political sphere (Fitzgerald would still be running for offices into his eighties, but without success), he settled down to summers at his palatial home at the base of Allerton Hill, facing the waters of Boston Harbor.

Originally, like most capable Boston Irish of his day, HoneyFitz, as he was now known for his sweet renditions of "Sweet Adeline," which he would sometimes sing when a debate turned boring, spent his summers at Old Orchard Beach, Maine. While serving as mayor of Boston, he purchased the Douglas estate in Hull, with a smaller house across the street, and invited friends from all over the world to join him there for the cooling breezes. Russell reported that even

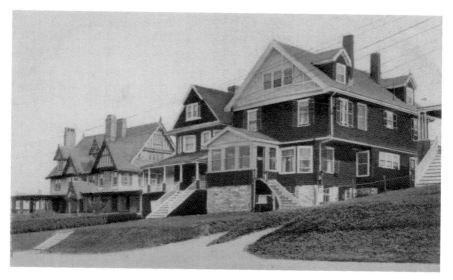

Sir Thomas Lipton once chased Rose Fitzgerald through the halls of her father's house, shown at left.

"Sir Thomas Lipton relaxed in his company, visiting him not only in Dorchester but in the wooden-gingerbread ark of [his] summer home in Hull, overlooking Boston Harbor."

Lipton did his best to win the hand of HoneyFitz's daughter, Rose, but her eyes by then had focused on young Joseph Patrick Kennedy, the son of the mayor's political contemporary, P.J. Kennedy.

According to William M. "Doc" Bergan, the author of Old Nantasket, Fitzgerald took the opportunity at a John Smith–run town meeting to verbally blast the Old Ring, Hull's political machine. The next day, town workers showed up at his home, dug a trench in his front yard and left. They did not return, in fact, until the end of the summer.

Fitzgerald left Hull for Wareham in the late 1920s, moving closer to what would later be known as the Kennedy Compound in Hyannisport. In 1915, upon the birth of his grandson Joseph Kennedy Jr. on Beach Avenue in Hull, he declared to the Boston newspapers that the baby would one day grow up to be president of the United States. Unfortunately, HoneyFitz outlived baby Joe, who died in 1944 on a high-risk mission over France during World War II.

Two years after this tragedy, Fitzgerald celebrated his grandson John Fitzgerald Kennedy's victory in the 1946 congressional race (in HoneyFitz's old district) by dancing a jig upon a table at the Bellevue Hotel and crooning "Sweet Adeline" one more time. He then announced that his grandson would one day be president of the United States, reiterating his dream.

John Francis Fitzgerald never did see his grandson achieve that dream, for he died in 1950. During HoneyFitz's eighty-seven years, he had traveled the path of rags to riches and set the stage for his descendants to act out the greatest American political drama ever written—the story of the Kennedys.

Floretta Versus the Young

Floretta Vining exuded power and confidence. And, luckily for Hull, she inherited a large enough fortune from her father to have the free time to put the irresistible force that was her will to good use for the town she called her summer home. She knew how to formulate an idea for the public improvement and had the strength of character (and that precious free time) to carry her demands all the way to Washington, D.C., if need be, to have her way.

Speaking to a Boston Post reporter for the article "Strenuous Life of 'Mayor of Hull': Miss Vining's Plans for Benefit of South Shore Towns" on August 18, 1901, Vining explained her methodology:

> *I suppose that I am the biggest society woman in or about Boston. I suppose that I attend more society functions of one kind or another than any woman of my age or weight about here. What am I going to do next? Why, young man, I have heaps of ideas…*
>
> *I go into a new town to improve it every year…I intend to have a rural delivery of mails for Hull. The route will commence in Hingham and go along the shore, ending with Pemberton, and abandoning the station at Surfside, which is no good. And I am going to make Hull a winter resort. The temperature here in winter is ten degrees higher than in Boston. Then there are many other things which I shall see that Hull has—and when I make my mind up to a thing, why the thing usually happens.*

In this way, Floretta Vining worked to improve Hull's roads, schools and overall daily life.

Yet, as she aged, Vining found that there was one battle she would seemingly never win, no matter how hard she fought and how loudly she spoke. Although progressive for her time and a firm believer in the rights of women achieving

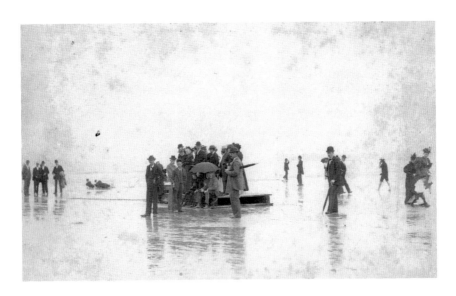

Floretta Vining felt that even during bad weather days, life in Hull was better than it ever was in Boston.

positions of social importance, she still felt that the road to success for young women began in the home. And in the young women of the day, she perceived the skills of bed making and bread making to be sadly sliding away.

Always an arbiter of good taste and continually aiming her newspaper editorials at instructing the locals on how to collectively grab for the next rung on the ladder of social Darwinism, Vining decried—for more than one reason—the breakdown in household training. For without enough young Hull women expert in housekeeping, there would no longer be enough household servants to work for the upper-class visitors she tried to attract to the summer resort.

In an editorial in the Hull Beacon on Friday, July 31, 1903, entitled "The Servant Question," she explained her cause for alarm: "What is to be done in the future… absolutely the girl of all work has gone out of existence. Years ago any young woman who was obliged to earn her living would go to a neighbor or friend and stay years, soon became one of the family and remained there until she married… Not so now; it is the shop and anything in the world to do but housework."

What Vining failed to take into account was that "years ago" the shops she spoke of did not yet exist. She grew up in a world on the edge of change. She spent the years of her youth in pre–Civil War Hull, with a population of about 250 hardworking, tied-to-the-sea types who lived very simple lives as fishermen and farmers. The Industrial Revolution changed all that; indeed, it made Hull the resort it had become, with quadruple the year-round

population and hotels, bars and various other places of entertainment to lure girls out of the home.

Yet Vining's problems with the younger generation ran much deeper than the mere failure of their desire to do housework. She had plenty to say about younger people in general by the time she turned fifty-five. She summed up her feelings in the opening paragraph of her December 20, 1907 editorial, "The Coming Generations":

> *I am thoroughly disgusted with the way that the young people of the present time carry on. It seems to me that they are indolent, saucy, impudent and very nearly worthless. They do not appear to have any knowledge of politeness; their manners are worse than those of savages, while knowing but a very little they think they are better informed than their fathers, and altogether they put on so many airs and act so outrageously that they are a nuisance...The rising generation may be all that it thinks itself, but I, for one, have my doubts.*

To lead her regular "Hull and Nantasket" column that same week, Floretta made a second reference to savages in describing the young people of Hull, in the opening words of her newspapers: "Wild, savage Indian tribes and their

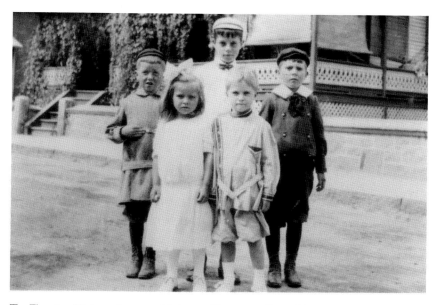

To Floretta Vining, there could be nothing so evil, nothing so anathema to the development of a community than...children.

screeches is no comparison to the noise, yells and screeches of some of the Hull girls as they get into the cars at Hingham to return home from the Hingham High school to Hull. Their conduct is unbearable, and the taxpayer objects to educating such as these and it has got to be stopped and immediately, too."

Vining herself had pushed through the legislation that enabled Hull students to travel to Hingham for high school, since no such school in Hull yet existed.

Although confident enough in the public's ability to temper its own drinking habits in 1901 to state, "I never drink, but my friends do, and I don't object to what they or any other people choose to do," within a few years Floretta would declare alcohol to be one of the main reasons for the downfall of otherwise promising young women.

As a matter of fact, the perceived "Habit of Drinking Greatly Increasing Among Women" had led her to the early stages of rigor mortis:

> *I am simply paralized [sic] with what I see and know about the great use of intoxicating liquors that are used by young women...I saw only a few days ago two young women, not yet eighteen, come into a well known hotel café and they at once ordered a whiskey cocktail, they took a light lunch and before they finished they had two bottles of beer each... Oh! What will those young women be at fifty years old? It is simply apalling [sic], the loose habits of the young people nowadays.*

On January 18, 1907, Vining reported to—or rather, threatened—specific young female readers that their actions needed immediate adjustment: "If four of the young women of Hull village don't stop having their pictures taken nude and conduct themselves better their names will be in public print and taken to court for better conduct."

In another editorial, entitled "Why Are Girls So Foolish?" on October 25, 1907, Vining lashed out at young women who attended secondary schooling, seeing such behavior as merely a ploy to escape housework.

> *I have no patience with the way in which the young girls of the present day try to obtain a superficial education, with a little familiarity with the dead languages, a trifle of French and just an insight into the mysteries of chemistry and astronomy, and then take up typewriting and stenography, when it would be better for them to learn household duties, and go into some good family as cook, second girl or chambermaid... But American girls have long since given up the work of cooks, chambermaids and table girls, and the Irish, who, forty years ago made*

Whether traveling alone or in packs, little boys were simply no good in the eyes of the editor of the Hull Beacon.

> *the best houseservants are beginning to feel that it is beneath their dignity to engage in such labor…What is poor beset housekeeper to do?*

The week before, in her editorial "Women of Today," she had blamed it all on the mothers.

> *The way in which many of the young women of the present time carry out their household duties is almost criminal. At summer resorts this deplorable condition is more noticeable than anywhere else. It seems that all the young matrons of the present generation whose summer homes*

are at the seaside care for is their own pleasure. While the head of the family is away at his place of business the women are out playing tennis, automobiling, boating or fishing…If there is anything I despise it is a careless, slovenly or ignorant housekeeper. And this is not the worst side of the matter either, for, I am sorry to say, not a few of the women indulge in harmless (?) flirtations with strangers whom they meet in the park or upon the beach. All the girls of my day were thoroughly skilled in household arts, but I am sorry to say they do not train their daughters in the same way that they were trained.

For the record, Floretta Vining never had children of her own.

As the controversy continued to rage inside her head, Vining's language became increasingly belligerent toward the younger generation. "I have no patience with the young people of the present day. They are utterly useless and are only of burden to their parents and friends."

And, of course, one thing led to the next. "And another thing that I have noticed, and it is perhaps the most deplorable of all, is the vile, disgusting and profane language used by the boys of today. Boys hardly big enough to be out of pinafores indulge in the most shocking language, and if an older person remonstrates with them he is insulted and treated to a tirade of obscenity and profanity that would shock the most hardened reprobate in the world."

And she saw selfishness as well. "They care nothing about their parents, and would see them starve and go to the poor house before they would lift a finger and aid them."

In the end, she refrained from using the "hell in a handbasket" analogy, but instead found biblical precedent for what she saw in the future. "I can see a day of reckoning for the rising generation. Sodom and Gomorrah were destroyed, and if the world goes on at its present pace there is a day of retribution in store for those who defy the just laws of man and nature."

Her cure, naturally, lay in a return to the values taught to her as a youth in the 1850s and 1860s, and in the ever-present "in my day" story. "When I was a girl the boys and the girls were taught to do housework. They could cook and wash and iron, make beds, dust and sweep and sew, and were familiar with all the duties appertaining to housekeeping. And above all they had respect for their elders." And as for women specifically,

In the old days the girls did not consider that their whole mission in life was to become ornaments. They were taught that life was a serious matter, and that as the home was the foundation of society it was their

duty to qualify themselves for the position of mistress of a home. The saying "the hand that rocks the cradle rules the world" may be as true today as it ever was, and I guess it is, for the rate at which the world is traveling on the road to ruin shows that the hand that rocks the cradle exceeded the speed limit, and the fast pace of the present generation is proof that the cradle was rocked too fast.

So what were the young women of Vining's childhood like in Hull? James Lloyd Homer wrote about the "decline of the noble science of cooking among the young ladies of the present day" in Notes From the Sea-Shore in August of 1845, four years before Vining was born:

The fact is, my dear colonel, forty years ago it was customary for the mothers of Boston to teach their girls to make chowders, to do every kind of domestic labor—well-knowing how to do those things themselves, for they were brought up in "times that tried the souls" of women as well as those of men; and you cannot find a "Boston girl," and I might add a "country girl," or forty years of age, at the present day, who, in domestic matters, does not understand every rope in the ship. But come down

If there was one place that young women did not need to be, according to Floretta Vining, it was in the company of strange men.

one generation—look into the spawn which is now coming forward, and tell me how many of our city "young ladies" know or care about cooking, making bread and cake, washing and ironing, of mending children's clothes, and the thousand other little minutiae incident to a well regulated domestic establishment and its accomplished head...for the most part, our young ladies are sent to school to learn the Italian and French languages—they have their musical instructors—they will attempt to play on the piano forte, with no skill at their fingers' ends, and to sing without any natural or acquired voice, and but little knowledge of the notes; and generally speaking with an indifferent "fashionable education," they are sent into the world, wholly ignorant of domestic matters, a prey to "help" hardly less ignorant than themselves. And, in after life, if misfortune comes upon them, they will begin to see how unwisely they were brought up.

But then, how did the ancient Romans feel about their children? Horace wrote in his Odes, "Our sires' age was worse than our grandsires'. We their sons are more worthless than they; so in turn we shall give the world a progeny yet more corrupt."

Floretta Vining simply fell victim to finally reaching the far side of the generation gap, and, like millions upon millions before her, she lost the battle to understand the actions of those younger than her.

A Local Factional Contest

U p until 1909, he was just John Smith. For a while he was patrolman John Smith, when he worked for the Hull Police Department, and in 1893 he became Selectman John Smith. It wasn't until 1909, though, that he became Boss John Smith.

In the fall of that year, the town of Hull was primed to exercise its agreed-upon right to send a local man to the state's House of Representatives from the local district. The agreement forged years in the past stated that Hull would send its local man to the House every ten years, with Hingham and Cohasset—with much larger populations—filling the interim seats. That's how Hull men like Lewis Pratt Loring had ended up in the House in years past. It was Hull's turn, and they were the cream of the town's crop at that point in their respective decades.

Yet even with the openly discussed arrangement in place, the process of choosing one Hull man for the job did not necessarily go smoothly every time it came around. The candidate for 1909, of course, would be a Republican, as since 1900 the Republican Town Committee had held full control of Hull's political present and future. The question came down to which Republican candidate would be nominated to trounce the local Democratic candidate and head for Beacon Hill.

Hull Beacon editor Floretta Vining set the stage for the upcoming contest with her August 27, 1909 editorial, "Politics in Hull." "There are two if not three candidates," she began. "One candidate, Mr. Clarence Nickerson, is treasurer of the town of Hull. He is also the head teacher of the Village school. He is a native of Cape Cod," she added, hinting that she knew his Barnstable birth might turn some voters against him. But Nickerson had the biggest backer in town. "He married the niece of John Smith, the Selectman of this town, and has made Hull his home."

Another candidate is Richard B. Hayes, a lawyer, a native of Hull, graduate of Hull school and Hingham high school. He has offices in Boston at 209 Washington street, Rogers building. He is chairman of the board of assessors of the town. Many feel that he is identified with the town being a native born, that he is entitled to represent us in the legislature. He has many followers in this idea, and they are determined that he shall be elected, but the decision will come with the voters at the caucus on Sept. 21st.

Yet, as stated, a third candidate for the Republican nomination stood in the way. Hingham's John Curtis had been ably serving in the position, and many in his hometown, not to mention Cohasset, felt that he should not be forced to vacate his seat simply because it was "Hull's turn" to send a candidate forward. Vining waffled on the subject. "It is feared that Hingham will take advantage [of the split sentiments in Hull between Nickerson and Hayes] and return Mr. Curtis who has so very ably and satisfactorily filled the position of

The 1909 state election offered the members of the Old Ring the chance to flex their political muscle. Shown here, among others, are John L. Mitchell and James Jeffrey in the front row and Boss John Smith, with the high white collar, in the background between them.

Representative. Never have we had a man in the Legislature who satisfied all his constituents as he has done."

In the space just below Vining's editorial, she ran a letter signed, "John Smith, Centre Hill avenue, Nantasket, Mass.," addressed "To the Voters of the Third Plymouth Representative District." Smith reiterated the "long standing agreement" between the communities and disclosed for those folks new in town a little bit of history about the process.

> *The last time Hull had an opportunity to furnish a candidate there was a local factional contest which was carried through the caucus and into the nominating convention and prolonged to an unreasonable extent and the result was Hull lost one year's representation and the Republicans of the whole district were defeated. Whenever selections have been made in Hingham or Cohasset the Republicans of those towns have been able to settle their differences and agree upon one candidate at or before their caucus and when his name was presented to the convention it was accepted and endorsed by the delegates from Hull.*
>
> *It behooves the citizens of this town and the Republicans of the whole district that the voters decide definitely at their caucus held in Hull, Sept. 21.*

Smith then went on to tell the voters exactly for whom it was that they should be voting.

> *There are many requirements and conditions necessary to fit one for the office, but none that should be more carefully considered from the points of political policy and good sense than that the candidate be acceptable to the whole district and can be elected at the polls in November.*
>
> *It is thought by many of the leading citizens of Hull that Clarence V. Nickerson, our present Town Treasurer, more nearly fills all these conditions than any other candidate mentioned.*

Vining echoed Smith's call for an orderly and cohesive communal selection, if not his plea for a specific candidate. "It is for the best interests of Hull that we should all come together, barring prejudices, and work for good and common cause."

Smith's letter ran again the following week on the front page of the September 3 edition of the Beacon, under a photograph of his endorsed candidate. The youthful Nickerson sported a bow tie, high collar and dramatic middle part of his hair, stylish among the young men of his time. On the right side of the page,

Hayes's sterner countenance portrayed his no-nonsense attitude and showed his balding scalp, a sign that maybe he had experienced more in life than the younger Nickerson and might be better suited for the job at hand.

The text accompanying the Hayes photo embellished the brief resumé penned by Vining the week before, stating that he consented to run for the office "at the earnest solicitation of his friends." The anonymous writer flaunted Hayes's Harvard and Boston University Law School degrees, his ten years as an assessor for the town and his military service as "one of the original members of Company K, Fifth Massachusetts Infantry of Hingham." And, in the tradition of the day, the writer used Hayes's association with local fraternal orders—the Old Colony Lodge of Masons, the South Shore Commandery Knights Templars and the Aleppo Temple Mystic Shriners—as proof of his connectedness with the leading men of Hull and the surrounding communities.

Then the fireworks began. Smith's letter of the previous week obviously touched a nerve within the Hayes camp, and the writer set out to dispel certain notions put forth by the selectman. "He [Hayes] is a life-long Republican, who has always supported the candidate of his party faithfully and loyally. Mr. Hayes has never been mixed up in any local factional contests," stated the writer, quoting directly from Smith, "but has always supported the nominee of the Republican convention." Next came the personal attack on the opposing candidate and his backer.

> *While other men in Hull who are considered among the leaders in the Republican ranks have either openly opposed the candidate of that party, or secretly lent their support to the Democratic nominee, Mr. Hayes has always given his earnest support to the man who was nominated by his party. He gave his earnest support to Dr. William H. Litchfield in 1900, when he was triumphantly elected, and again in 1901, when although he was the unanimous choice of the Hull caucus, and of the district convention, he was beaten by the vote of his own town.*
>
> *Mr. Hayes was never connected with any factional contest, but has always been a consistent, steadfast and unswerving supporter of Republican principles and men. He never bolted or sulked in his tent. He possesses all the requirements for the position, and the conditions point to him as the most available and best fitted candidate named.*

As the Republican caucus neared, the campaigns gained momentum. On Friday, September 17, the Beacon reported, "Richard B. Hayes, the Hull candidate for the Republican nomination, is developing unexpected strength at

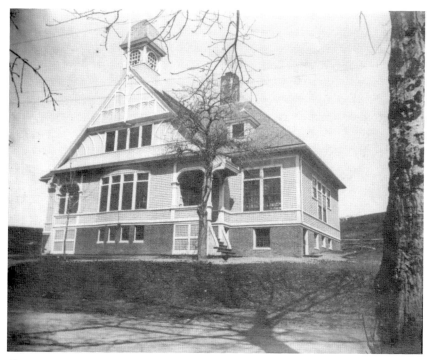

Clarence Nickerson, the Old Ring's candidate for state representative, served the town as, among other things, a teacher in the Hull Village School.

the Nantasket end of the town, where it was supposed that his opponent would have the unanimous support of the Republican voters." John Smith and the Republican Town Committee had tightly held the "Golden Mile" since the years before 1900. Oddly, though, the same column stated, "The Hayes family will make a change in place of residence. They have selected Brookline, Mass." Even before the election arrived, Hayes had decided to move his family out of Hull.

But before the Hayeses could pack their bags, a third party—literally—was heard from, in the same edition of the paper. A letter writer signing his name as R.E. Bisbee entered the public forum known as "The Arena," the Hull Beacon's letters-to-the-editor section, with a missive fired from the ranks of the local temperance party.

> *The temperance organizations of the state have united for the purpose of securing the passage of a law which provides in substance as follows: "That a saloon keeper having the privilege to sell liquor to be consumed at the bar or on the premises, cannot also sell liquor to be carried away in bottles or other containers."*

Its effect would be to prevent men whose appetites are inflamed and whose judgments are obscured by the liquor already drunk from buying more liquor to be carried away from the saloon and to be consumed on the street, in the train, or at the home. The purchase of bottles of liquor is often pressed by barkeepers upon drinkers already partly intoxicated, especially near the closing hour late at night. This results in a material increase in drunkenness with its accompanying evils of brawls, insults to decent travelers , arrests, disgrace for the victims, and misery for their families.

This bill would also prevent the sale of liquor to be carried from saloons into poverty-stricken homes in pitchers and pails, often to be consumed by women and children.

This bill has the unqualified support of the Anti-Saloon League, the Catholic Total Abstinence Societies, the Associated Charities, the sixteen settlement houses of Boston, men of such standing as ex-President Eliot of Harvard University, and ex-Governors Bates and Long, and more than three hundred other leading business and professional men of Massachusetts.

Bisbee then endorsed one candidate and rained fire upon the other. "These temperance organizations will support no man for the legislature who will not pledge himself to vote for this bill. Mr. Hayes has so pledged himself...Because of the character if the man who is backing him," added Bisbee, locking his crosshairs squarely on John Smith's forehead, "Mr. Nickerson will not be asked to pledge himself to this bill." Then, in direct opposition to Vining and Smith's pleas for a simple nomination process, Bisbee threatened the worst punishment of all. "If Mr. Nickerson is nominated, his election will be strenuously opposed by the combined no-license forces. If necessary, an independent candidate will be run and Hull may lose its opportunity to furnish a representative. The only safe way is for the Hull Republicans to nominate Mr. Hayes."

Bisbee then ended his letter by referring to a story the Hull Beacon had specifically avoided, as its editor, Vining, had made a pledge of her own never to run stories exposing the seamier side of Hull. "The failure of the Hull officials to enforce the law, as in the Peddocks island case, now a matter of court record," he wrote, "has made their candidate an impossibility. The situation has been created by themselves and they have no one else to blame."

William M. "Doc" Bergan later described the "Peddocks island case."

In the summer of 1908, the State Police got wind that gambling was going on at the two inns on Peddocks Island. They raided the place and arrested one proprietor but couldn't find the other. After they rowed the prisoner back

to the mainland he told them that his name was John Irwin, Chief of Police of Peddocks Island. After a consultation, in the barroom of the Pemberton Hotel, his innocence was established and they let him go. In the 1908 Town Book, Irwin was appointed by the Selectmen a special policeman without pay for Peddocks Island. The "chief" business was his own invention.

Irwin had also earlier been involved in a separate incident involving pickpockets, alcohol and an Irish organization's annual outing. Bergan wrote,

At that time, John Irwin operated a café and picnic ground on Peddocks Island just off the tip of the town. An Irish Society hired the picnic grounds for their annual outing. The pickpockets thought that was a good place to go to work. After the barrels were rolled out and the members were feeling fairly decent, a pickpocket walked up and punched an Irishman in the mouth, then stepped back so another Irishman was closer than he was. The one he hit hauled off and pasted the first face he saw and the whole picnic grounds was in a hell of a free-for-all. When the battle finally cooled off, most of the Irishmen's watches and wallets were gone. The Irish Society learned their lesson and learned it well.

They came back the next summer for their annual outing. This time they were slow in rolling out the barrel. They carefully counted noses. They found out that there were nine strangers in their midst. They watched carefully for the same thing to happen, and sure enough it did. One of the pickpockets punched an Irishman in the face. This time they nailed the pickpocket, gave him an unmerciful beating and dragged him away. Aside from the operators of the café, as near was known, the only ones to leave the island alive were the members of the Irish Society. Three of the pickpockets' bodies were washed ashore on Nantasket Beach and no one ever found out what happened to the other six.

Public drunkenness was certainly on the rise in Hull. The arrest reports of the Hull Police show that 91 intoxicated individuals had been taken into custody in 1900, with a slight dip to 58 in 1901 and 72 in 1902. The police apprehended 116 drunks in 1903; 163 in 1904; 190 in 1905, the year that Paragon Park opened; 203 in 1906; 166 in 1907; 250 in 1908; and 230 in 1909. Disturbing the peace charges were filed against 4 people in 1900 and 23 in 1909. No arrests were made in 1900 for "profane and indecent language," but in 1908, 8 people were so charged. Indecent exposure was also on the rise, as was public fornication (somehow, a single man had been arrested under this charge in 1905) and 1909 saw the first

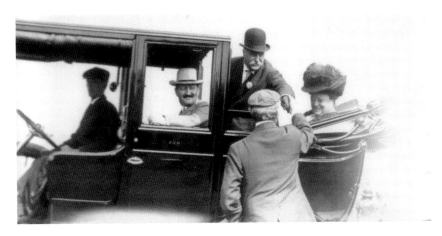

One candidate who came through the state election of 1909 unscathed was Governor Eben Draper. Courtesy of the Quincy Historical Society.

2 arrests in Hull for "violation of automobile laws." With the concurrent rises in public drinking and automobile ownership, it was only a matter of time before the first arrests for OUI, today's acronym for operating under the influence of alcohol, were recorded. They came, 3 of them, in 1913. From a low of 102 total arrests made in 1900, that total climbed to 348 in 1908, the year in which Irwin was arrested for "keeping a place of gaming" with 24 others who were arrested for "being present where gaming implements were found."

The statistics show that either John Smith and the Old Ring had let things get out of hand in Hull, as more arrestable offenses were being perpetrated, or that the number of arrests corresponded with a crackdown on crime. In any event, the growth of the summer community had placed an enormous strain on the small town police force. The 348 arrests in 1908 represented one third of the total year-round population of Hull.

The attacks on Smith and Nickerson did not end there. A letter signed by a "Citizen of Hull"—the Beacon did not require letter writers to publicly identify themselves—debated whether or not Nickerson could balance the town's priorities if elected.

> When a man who has held the position of principal of one of our schools for 12 years is induced to enter the political arena and strive for a nomination, it is about time to call a halt.
>
> If the schoolmaster-candidate succeeds in being elected, it will be necessary for him to relinquish his duties as teacher for at least a portion of the

school-year from January 1st to July. It is understood that if he is elected he is to be given a leave of absence during the time he is serving the state, and will resume his duties as school-teacher as soon as his term in the legislature ends.

This is not fair to the man who teaches the school during the candidate's term of office as a law-maker.

The "Citizen's" distrust of Smith, in particular, became more obvious as the letter continued, and this anonymous opponent to the Republican Town Committee's current efforts next tabbed the selectman with the nickname that would stick with him the rest of his life.

If the political boss can take a teacher away from his school, send him to the legislature and hold the place of teacher for him indefinitely, then it is about time that there should be a change in teachers and bosses.

It is to be hoped that the ruler of the town and the teacher himself will receive a well-merited rebuke at the caucus. Keep the schools out of politics and teach bossism a lesson.

And so "Boss" Smith was born.

But for Smith, the worst reading was yet to come. Still in that same September 17, 1909 edition of the Hull Beacon, yet another personal attack was leveled at him, one that did its best to expose the true character of the man at the head of the political machine. Signed by "A Voter," the letter entitled "Bossism in Hull" provided a trip to the woodshed in venomous prose.

The present campaign for the nomination of a candidate for the legislature by the Republicans of the Third Plymouth District has developed a decided case of bossism in politics. One of the candidates for the nomination was proposed by a member of the board of selectmen, who vouches for him, and he is fighting his battles. It is safe to say that no other voter in town would have thought of asking our schoolmaster to run for the office.

He recently published an article, over his own signature, endorsing the candidacy of his nephew by marriage, and, as near as can be learned, is his sole backer. But as he feels that he has the power to force the nomination, he will leave nothing undone that would be necessary to accomplish his purpose.

The "Voter" then went on to a more thorough, and damning, clarification of the 1899 rift in the Hull Republican Party.

In his published articles, two weeks in succession, he claims that the defeat of the party candidate nine years ago was due to factional contests in the Republican ranks, when as a matter of fact there was no factional quarrel at all, and Dr. Litchfield was the only candidate mentioned in the caucus or convention. The year before Dr. Litchfield was the candidate and received the entire support of his party among his most enthusiastic supporters being the selectman. He took off his coat and worked to get the doctor the unanimous vote of the town and nearly succeeded. Dr. Litchfield carried Hull by a practically unanimous vote.

The next year this leader of the Republican party did nothing to help the party candidate, but quietly permitted him to be slaughtered at the polls. When Reginald L. Robbins was the candidate at the following election, he did nothing for him, but, it is stated, quietly gave out the instruction that he would not be sorry to see him defeated. Again, when Harry E. Mapes of Cohasset was the candidate, he failed to use his influence to elect him.

He has on several occasions required Democrats to go into Republican caucuses, when he had some candidate that he wanted to present. In the Bates-Douglas campaign, he did not work overtime in trying to carry the town for the Republican candidate, when it was a well-known fact that a word from him would have carried the town for Gov. Bates.

If the voters of Hingham and Cohasset desire to support the candidate of a man who on several occasions permitted candidates of the party from those towns to be beaten in Hull, they may not hope for any improvement in the reliability of the vote of Hull.

Richard B. Hayes has always supported the candidates of the Republican party from Governor down to Representative.

John Smith took all of the attacks in stride. After all, as Bergan stated in Old Nantasket, "The Old Ring could support a wild baboon in a cage against a clergyman of the Gospel and the gentleman of the cloth would surely go down to ignominious defeat."

In the meantime, the opposition gathered their forces. The prohibitionists organized a rally at town hall, inviting John A. Nichols, a candidate for governor, to come to town and speak before the masses. The Boston Post reported that Ellery Clark, a former Boston alderman and the only man to ever win the Olympic Gold Medals in both the high and long jumps, which he did at the first modern games in Athens in 1896, registered to vote in Cohasset specifically to support Hayes in the fight against John Smith.

Whether he needed it or not, another anonymous letter writer, also calling himself "A Voter," came to the defense of John Smith in the September 24 edition of the Beacon.

> *I have seen the boss work hard for his people in various ways but I have never seen any credit given him. What did he and John Mitchell [former chief of the fire department, owner of a coal wharf at A Street and Smith's brother-in-law] do at the time of the coal famine a few winters ago? I have heard him give John Mitchell, then chief [of police], some very strong advice about enforcing the liquor laws and in those days they were enforced to the full extent, and I was in a position to know this for a fact, and I do believe that today if the boss had his way conditions would be far different in Hull. The usual political mud has been thrown all over him because he has endorsed a man who can ably master the position, and I have seen him go to the rescue of many a poor unfortunate and make their sufferings turn to happiness...I would say that Clarence V. Nickerson will be the next representative and Cohasset, Hingham and Hull will honor and respect him and praise John Smith for the many good deeds he has done for Hull.*

Richard Hayes, who had fallen seriously ill during the summer, in the meantime made his first trip into Boston in recent months in hope of catching up on delayed work. The prohibitionists rode a water wagon driven by former Selectman Edward G. Knight and a canopy wagon with former Beacon editor David Porter Mathews at the reins from Pemberton to Whitehead and back on Wednesday, September 29, advertising that evening's rally. After speeches by Mathews and gubernatorial candidate Nichols, "Many who had not voted the ticket before announced their intention of doing so this year," reported the Beacon on October 1.

Finally, during the week of October 15, the local Republican Party decided once and for all to repair the rift that was apparently not taken care of at the September 21 caucus.

> *At the close of the Republican convention at the Hose House one night last week, the delegates adjourned to Smith's Tavern [owned by George Smith, not John], where they sat down to a feast such as Lucullus never knew. The two candidates for the honor, Clarence V. Nickerson, who was successful, and Richard B. Hayes, who gave the victor such a close run, sat at the head of the table. All their differences were amicably settled, and the banquet was in the nature of a love feast.*

It was, in fact, a last supper for Hayes. He and his family moved out of town that week, although they continued to maintain a residence on Spring Street. Although listed as chairman of the board of assessors with a term expiring in March 1911, he did not return to his seat the following March and a new person was handpicked to replace him by John Smith. "For twenty-six years, from 1893 to 1919, there were no town election days," wrote Bergan in Old Nantasket. The town reports from this era support that statement, as there are no election results given after town meetings, just lists of men and women appointed to offices.

As Election Day neared, the Democrats introduced their regional candidate, George A. Cole of Hingham. They also dispelled a rumor sent forth from the Boston Globe that Hull only had three registered Democrats. The Beacon reported on October 22, "Last year, Mr. Vahey, the candidate for governor, polled 55. It is expected he will receive about 75 next month."

The Cohasset Sentinel (the Hull Beacon under a different banner) reported on October 29 that a certain constituency within that community would simply be voting anti-Hull. "On account of the way in which the voters of Hull treated Jason M. Eunice of this town when he was a candidate for representative a few years ago, when that town voted almost solidly against him, every voter of Portuguese birth or ancestry will vote against the Hull candidate."

The Hingham Bucket (another of the Vining syndicate of South Shore newspapers) recapped the alleged shenanigans of Smith and his cohorts.

The vote of Hull in critical years was in 1901, W.H. Litchfield, Rep. 147; Thos. H. Buttimer, Dem. 55. The following year Mr. Buttimer beat Dr. Litchfield in Hull receiving 161 votes to 127 for Dr. Litchfield. In 1905 when Reginald L. Robbins was the Republican candidate he received only 60 votes, Buttimer getting 195. Two years later when Harry Mapes of Cohasset was the Republican candidate, Hull gave him 95 to 172 for Buttimer.

The Bucket also reported, though, that the Republicans were set for a final rally on Saturday night, October 30, at Loring Hall, with ex-Governor John Davis Long in attendance and with Nickerson and the Honorable Dana Malone, attorney general and civil service commissioner, expected to speak.

Finally, at the last moment, Floretta Vining let her preference be known, in the last paragraph of her Hull Beacon column on Friday, October 29. "Mr. Nickerson of Hull will be elected Representative, and all will meet a gentleman who is always kind and courteous and attentive to his business, doing his part in life well. F. Vining."

What came next can only be described at the least as odd and at the most, shadowy. John Smith had demonstrated, through the Hingham Bucket rundown outlined above, that he could convince Republicans to vote Democrat when it suited the town's needs. But in this instance, he professed to do just the opposite, to sway the fifty-five or so Democrats in town to vote Republican and vault Nickerson to victory. And in this election he also had the momentum of the Prohibition Party pushing against him.

In the 1909 Report of the Financial Affairs of the Town of Hull, Town Clerk James Jeffrey (who was also a selectman) stated that on Tuesday, November 2, 1909,

> *The ballot box was examined and the register placed at zero before voting began. Promptly at four o'clock P.M. the polls were declared closed and the number of names checked on the voting box as having voted was found to be 282. The ballot box register showed 282 and the number of ballots taken from the box was found to be 282 and they were sorted and declaration thereof made as by the Statutes required.*

With such a small number voting (Hull's population had barely broken 1,000 in 1900), statistical analysis of the results was a simple game. The town voted, as expected, overwhelmingly Republican. For governor, incumbent Eben S. Draper of Hopedale defeated challenger James Vahey, 165 to 88. For lieutenant governor, Louis Fronthingham of Boston outraced future governor Eugene N. Foss, a Republican running as a Democrat, 154 to 85.

The rest of the contests had remarkably similar results. For secretary, William Olin beat out David T. Clark, 157 to 51, with 62 blanks; treasurer went to Elmer A. Stevens over James H. Bryan, 156 to 53, with 62 blanks; auditor, Henry E. Turner over Alexis Boyer Jr., 162 to 45, with 65 blanks; attorney general, Dana Malone over Harvey N. Shepard, 156 to 51, with 61 blanks; councilor, first district, Charles O. Brightman over Thomas F. O'Brien, 163 to 46, with 67 blanks; senator, first district, Melvin S. Nash over John M. Hayes, 159 to 51, with 62 blanks; county commissioner, Lyman P. Thomas over Edward P. Boynton, 164 to 46, with 69 blanks; for county treasurer, for which there was no Democratic candidate, Horace T. Fogg of Weymouth won with 171 votes, and 97 left blank.

Although the Republicans made a clean sweep of the election, the results for the race for representative certainly required a second glance. Although the Republicans had consistently cast between 156 and 164 votes in all of the other contested races, excluding governor and lieutenant governor, Nickerson drew 252 of the 282 votes cast. The Democrats, who posted between 45 and 53 votes for their candidates, only cast 19 for George A. Cole of Hingham. The

third candidate, Harold G. Leavitt of Hingham, of the supposedly mighty and threatening Prohibition Party, received 5 votes. And where there had been a consistent 61 to 69 blanks through the above-mentioned contests, the battle for representative polled only six blank ballots. John Smith had not only convinced the local Democrats to vote Republican, but he also somehow persuaded approximately 56 men who otherwise did not vote in any contest other than governor and lieutenant governor to help him elect Clarence V. Nickerson.

But the battle in Hull was only one third of the war. Ten days later, the town clerks of Hull, Hingham and Cohasset gathered at the Hingham town offices at high noon to compare election results. Leavitt fared better in Hingham than he did in Hull, gaining thirteen votes, but worse in Cohasset, where he received four, for a total of twenty-two. The real contest came down to Cole and Nickerson.

Cole took two of the three towns, capturing 51 percent of the Hingham vote, 407 to 366, over the Hull candidate, and 62 percent of the Cohasset vote, 264 to 145. Yet in Hull, his measly 19 votes totaled less than 7 percent of the number cast, a dramatic drop-off from the rest of the results. Taking the mean averages of the other Hull elections—a 30 Democrat-Republican vote swing, and a 59-vote change from blanks to Republicans for representative—we find a difference of 89 votes in favor of Nickerson that statistically should not have been there. Of the 1,507 votes cast, Nickerson boasted 763 and Cole 690. Had those 89 votes not mysteriously swung his way in Hull, Nickerson would have been soundly defeated. Instead, he was on his way to Beacon Hill, thanks to his "sole backer," John Smith.

The town clerks—Fred H. Miller of Hingham, Harry F. Tilden of Cohasset and Jeffrey—wrote, "It appearing that Clarence V. Nickerson of Hull had received a plurality of the votes given in, a certificate of election was issued to him," and the clerks signed their names.

Floretta Vining could not help but gloat. "The election is over," she wrote in the November 5, 1909 edition of the Beacon. "Mr. Nickerson will go to the Legislature and all the men on Beacon Hill will enjoy the acquaintance of Treasurer Nickerson of Hull as we have said before."

In other words, "We told you so."

Smith and Nickerson carried out their intended plan and took advantage of the opportunity to put a Hull man in the legislature every ten years. More importantly, though, for the future of their party, they forced out a man who they considered a malcontent in Richard Hayes and flashed the power that they so strongly strived for with each election or town meeting in Hull. Hayes was the first to openly wage war on the Republican Town Committee, but he would not be the last. The toughest fight of all was yet to come, and from a thoroughly unexpected place.

Floretta Versus the Elderly

In most of her Hull Beacon editorial columns, Floretta Vining expressed opinions held by many of her contemporaries. Yet while most people found ways to quietly and politely register their discontent or even disgust with gum chewers, pipe smokers and lazy servant girls, Floretta planted her feet firmly on her soapbox and flung her opinions to the Nantasket breezes, utilizing language intended to awaken the dead.

Occasionally, though, the "Mayor of Hull" expanded the scope of her editorials from simply carping about what she considered to be bad manners displayed by members of the "rising generation" to well-thought-out missives on contemporary philosophical issues. Sometimes her views lined her up on the side of the majority, and at other times she stood alone against the masses.

One of her most startling revelations came in her March 26, 1909 column: "Why prolong life needlessly?" Through that editorial she let the world, or that little corner over which she had editorial power, know her desires for a systematic removal from society of anyone over the age of sixty years. To reach her belief that chloroforming the sexagenarian population would be good for the planet as a whole, Floretta reacted to the writing of two men: British novelist Anthony Trollope and Canadian doctor Sir William Osler.

Osler was born on July 12, 1849, in Bond Head, Canada West (now Ontario), the youngest of nine children. Although his parents—the Reverend Featherstone and Ellen Osler—intended for young William to study for a life as a clergyman, the boy gained a fascination with the study of natural history after reading a copy of Religio Medici while away at school.

After leaving Trinity College, he enrolled at Toronto Medical College in 1868, then transferred to McGill University in Montreal and earned his MD in 1872.

In Floretta Vining's perfect world, scenes like this one inside the Straits Pond House would never take place.

In 1873, while touring the medical facilities of Europe, Osler began the first true intensive study of blood platelets, the smallest cellular elements of blood, hitherto unidentified. His research on the platelets (or thrombocytes) led to the discovery of

their importance in blood coagulation and certain immunological reactions. Osler fondly recalled his periods of travel and research as his "brain dusting" days, times to freshen memories and explore new techniques and studies.

Osler became a professor of medicine at McGill in 1875 and pathologist to Montreal General Hospital in 1878. Six years later, he literally flipped a coin to determine whether he should accept the post of chair of medicine at the University of Pennsylvania at Philadelphia; the odds fell in the school's favor. While there, he helped found the Association of American Physicians.

In 1888, he accepted an invitation to become Johns Hopkins University Medical School's first professor of medicine, in Baltimore. With fellow doctors William H. Welch, Howard A. Kelly and William S. Halsted, Osler helped make Johns Hopkins the most famous medical school in the world. No students attended the school for the first four years while the doctors developed their curriculum of clinical teaching. Osler used the time to his best advantage, writing The Principles of Practical Medicine, published in 1892, a model for all later medical textbooks.

Osler spent more than fifteen years at Johns Hopkins, influencing "medical teaching throughout the United States of America, combining the bedside methods of the English School with the laboratory methods of the German," wrote Walton in The Oxford Medical Companion. In 1901, Osler became the first physician to describe hereditary haemorrhagic telangiectasia, or Osler-Rendu-Weber disease, a genetic disorder characterized by multiple patches of telangiectasia (dilatation of small blood vessels) on skin and mucus membranes, especially in the nose, mouth and gastrointestinal tract, and on the hands and feet.

In 1903, his research led to the classification of polycythaemia vera, or Vaquez-Osler's disease, an increase above normal in the total circulating red blood cell mass, often a reaction to a prolonged shortage of oxygen. In 1909, he associated painful pea-sized nodules in the pads of fingers and toes (known as Osler's nodes) with the diagnosis of infective endocarditis, an infection that attacked one or more weakened or defective endocardium overlying heart valves, invariably fatal before the discovery of antibiotics.

In 1904, while visiting England, Osler received an invitation from Oxford University to take its Regius Chair of Medicine, a position appointed by the British Crown. His wife, knowing that his time and energy were both running out, telegraphed him from across the Atlantic upon hearing the news, "Do not hesitate. Accept at once."

On February 22, 1905, the celebratory day of the founding of Johns Hopkins University, Osler delivered his farewell speech to the school where he had spent the last decade and a half of his life.

Over the course of his medical career, Osler had delivered numerous speeches on a wide variety of topics. Many of his lectures had been collected and published. On the side, he showed his wit through medical nonsense fiction under the nom de plume Egerton Yorrick Davis, a supposed retired surgeon captain of the United States Army. His wit, though, would nearly cause his downfall, thanks to the omnipresent hordes of yellow journalists who were always looking for good copy in slow times during that period.

At McCoy Hall, before an unprecedented gathering of Johns Hopkins alumni, Osler read a speech entitled "The Fixed Period," inspired by the little-read novel of that name by Englishman Anthony Trollope. As a fifty-five-year-old sometimes-tired doctor, Osler focused his discussion on the benefits of a changeover in personnel at a university and the dangers of staying too long in one place. Then, self-deprecatingly, he moved on to his two "fixed ideas":

The first is the comparative uselessness of men above forty years of age. This may seem shocking, and yet read aright the world's history bears out the statement. Take the sum of human achievement in action, in science, in art, in literature—subtract the work of the men above forty, and while we should miss great treasures, we would practically be where we are at to-day. It is difficult to name a great and far-reaching conquest of the mind which has not been given to the world by a man on whose back the sun was still shining. The effective, moving, vitalizing work of the world is done between the ages of twenty-five and forty—these fifteen golden years of plenty, the anabolic or constructive period, in which there is always a balance in the mental bank and the credit is still good.

While Osler defined men over forty as merely comparatively useless, he jokingly found that men just two decades older had lost all usefulness to society. He suggested that once that age had been attained a man should be pulled away from all work, pointing out that such a scheme had once been implemented in ancient Rome.

In that charming novel, The Fixed Period, Anthony Trollope discusses the practical advantages in modern life of a return to this ancient usage, and the plot hinges upon the admirable scheme of a college into which at sixty men retired for a year of contemplation before a peaceful departure by chloroform. That incalculable benefits might follow such a scheme is apparent to anyone who, like myself is nearing the limit, and who has made a careful study of the calamities which may befall men during the

seventh and eighth decades. Still more when he contemplates the many evils which they perpetuate unconsciously, and with impunity. As it can be maintained that all the great advances have come from men under forty, so the history of the world shows that a very large proportion of the evils may be traced to the sexagenarians—nearly all the great mistakes politically and socially, all of the worst poems, most of the bad pictures, a majority of the bad novels, not a few of the bad sermons and speeches.

In conclusion, though, Osler pulled back from his tongue-in-cheek proposal of a world in which birth certificates would come with expiration dates. "The teacher's life should have three periods, study until twenty-five, investigation until forty, profession until sixty, at which age I would have him retired on a double allowance. Whether Anthony Trollope's suggestion of a college and chloroform should be carried out or not, I have become a little dubious, as my own time is getting short," recorded Harvey Cushing in The Life of Sir William Osler.

At the reception after his speech, Osler's friends and colleagues ribbed him endlessly about his words, understanding his humor and knowing he meant to do nothing more than get a laugh out of them. The journalists covering the event smelled a story and called in their front-page news.

As long as men retained useful and gainful employment in this world, according to Floretta Vining, they earned the right to stay alive. For the moment, these men at Hastey Brothers hardware were safe.

Cushing wrote,

> *The storm did not break until the next day, when it was headlined throughout the country that "OSLER RECOMMENDS CHLOROFORM AT SIXTY," and for days and weeks there followed pages of discussion, with cartoons and comments, caustic, abusive, and worse, with only an occasional word on his behalf lost in the uproar…Knowing nothing of the whimsical reference to Trollope's novel, interposed to mask his own pain at parting…the public at large felt it was the heartless view of a cold scientist who would condemn man as a productive machine.*

Osler took a conservative approach to weathering the national torrent of protest. "I took my old Master, Plato's advice & crept under the shelter of a wall until the storm blew over—working hard and reading nothing about it."

In short time, Osler would be away from Baltimore and off to England, where he could begin anew. If not for his outstanding reputation as one of the world's hardest-working and most competent physicians his public career would have come to an end. Instead, he continued to work for another decade before passing on in 1919, spiritually broken by the loss of his son Revere in the First World War.

Floretta Vining apparently never learned of the comedic intentions of Dr. Osler's farewell speech. She took the words straight to heart and even added her own interpretation and stipulation to the proposal in 1909.

> *[Dr.] Osler said that, under existing conditions and on account of the present industrial system, where life was a constant struggle, the world had no use for a man over 40, and that he ought to be chloroformed when he attained the age of 60. He undoubtedly referred to the great majority of people who had not accumulated sufficient wealth to maintain them for the remainder of their lives. Many people will agree with him in that.*

In just two months' time Floretta would turn sixty, but, according to her theory anyway, even if society had implemented a scheme, she would have been spared. As the sole heir of her father's fortune, she would always be able to support herself.

While Floretta saw potential in a system of "Oslerization," as the theory came to be known, she definitely wavered on the cutoff age. "I have known men who were at their best after 60. Perhaps they were not able to do laborious work as they had been, but they were more careful in their labors, more faithful to the trust confided in them, and more anxious to please and to do their work well."

It must have been difficult for readers of the Hull Beacon to figure out who Floretta Vining liked less, the young or the old. These first and second graders at the Damon School in 1913 had no idea what awaited them in the local newspapers editorials.

In fact, as usual, she found a way to blame the youth of the day for the problem. If, she reasoned, they would just understand that life should be more work than play, then we would not have to exterminate the elderly. "It is natural for the young to love pleasure, to avoid work, and to try to turn the stern reality of life into a picnic. When a person arrives at maturity it is a condition, not a theory, that confronts him, and he recognizes the fact in order to live one must work. When the young people appreciate this, there will be no need discussing this question of providing for people who have grown old."

It may have seemed odd to the readers of the Hull Beacon the week of March 6, 1909, that the editor had chosen to respond to Dr. Osler's speech when she did, four years after he had left the country for Oxford. She soon revealed her motivation.

If Dr. Osler is right in saying that all persons over 60, whose opportunity is gone, ought to be chloroformed, what can be said of the physically deformed, incurably diseased, morally perverted, abnormally distorted, and mentally unsound? Would it not be a mercy to those so afflicted, a blessing to their friends, a relief to the community and for the

advantage of the human race if there was some law by which such could be quietly removed from their condition of helplessness and suffering, and the community relieved of their presence?

I have lately had my attention called to a hospital supported by the state, to which persons sentenced to imprisonment for a crime are admitted. There are about 100 patients in the hospital, none of whom will ever leave there alive. Many of them have lost their minds, others have lost the use of their limbs, and still others are hopelessly deformed. They are of no use to themselves nor of interest to any one else.

Why would it not be a good plan to end all this misery and suffering by gently removing the hopeless cases? A sleeping draught, from which there would be no awakening, the sufferer or afflicted person quietly sent hence, and the state of the community relieved of the burden of supporting and caring for them. They have nothing to live for, are already dead to the world, and are serving no useful purpose in living, nothing but sentiment that prolongs their lives.

Floretta, an endless traveler and investigator, had finally stumbled onto what she considered to be one of the saddest spots on earth, a place where society had swept under the rug its children who had misbehaved. As far as Floretta could see, although they had been removed from interacting with the rest of the world, they could be swept even farther away.

We may never know how Floretta's reading public felt about her thoughts, for although she did offer a letters column under the title "The Arena" in her weekly papers, she garnered no responses to this particular editorial. From the storm of indignation and ridicule that Dr. Osler received for his words, we may assume that Floretta's thoughts were unpopular.

What started out as a fictional piece by Anthony Trollope in the mid-nineteenth century became a misinterpreted joke by Sir William Osler. Thanks to Floretta Vining's taking Osler's words as gospel, her readers a century ago got a shocking glimpse into the inner workings of her mind.

The Lost Prince

C all it what you will, the Kennedy mystique or the Kennedy legend. But there is just something about the rise to power of America's first family and their heartbreaking string of tragedies that causes our ears to perk up whenever we hear the name mentioned.

Several Massachusetts communities, such as Hyannisport and Brookline, stages on which acts and scenes in the lives of the Kennedys played out, hold tightly to certain aspects of that family's lore. Other towns, like Chappaquiddick and Cohasset, would rather downplay their connections to Kennedy indiscretions. Hull safely resides amongst the former grouping, as the birthplace of the oldest child of Joseph Patrick and Rose Fitzgerald Kennedy, the nearly forgotten World War II hero Joseph P. Kennedy Jr.

A century ago, Hull beckoned indiscriminately to summer visitors to participate in the frivolity of the amusements both natural and manmade on Nantasket Beach. The demographic layout ranged from factory workers who saved just enough money to board a steamer, buy a few drinks at a beachfront saloon and head home again once a summer, to Presidents Grover Cleveland and William McKinley.

Between those two extremes, though toward the higher end of the social scale, walked several prominent Boston politicians. Mayor-elect Patrick N. Collins rented a home on Allerton Hill in 1902, but vowed never to return after falling ill with a bad case of rheumatism he felt attributable to the air quality inside the dwelling. James Michael Curley delighted Hull Village children with exciting July Fourth fireworks displays from the lawn of his Spring Street home and enjoyed digging for clams out on the tidal flats at the base of Gallops Hill. Silent Cal Coolidge spent time on Hull Hill, as did Governor Charles Hurley, whose respectable presence remains vividly in the memories of a number of Hull residents today.

While waiting for their son to be born, Joseph Kennedy and his wife Rose visited the attractions at Nantasket Beach, including listening to the bands that played at Paragon Park.

Boston's thirty-fourth mayor, John F. "HoneyFitz" Fitzgerald, sang his way into office in 1906, plastering the walls of the twenty-four wards with posters promising a Bigger, Better, Busier Boston, and crooning "Sweet Adeline" at each stop on his whirlwind tour of the city's soapboxes. Choosing to summer in Hull, he bought a stately Tudor-style mansion at the base of Allerton Hill, complete with separate servants' quarters across the street. Young Rose spent many of her early summers there avoiding the amorous advances of men such as Sir Thomas Lipton, the meatpacking and later tea mogul and yachting enthusiast. Her one true love would instead be the son of Patrick J. Kennedy, one of HoneyFitz's Board of Strategy members.

Although Fitzgerald railed at the idea of their union—going so far as to send his daughter to a Prussian convent to keep her from a relationship with him—Rose married Joe Kennedy anyway, hoping the young Harvard-educated banker would keep his promise to make his first million before the age of thirty-five. They exchanged vows on October 14, 1914, in the private chapel of Cardinal William O'Connell, honeymooned at White Sulphur Springs and then bought a house on Beals Street in Brookline. The following spring, it became quite evident that the newlyweds were expecting the arrival of their first child. Although Fitzgerald had by now raised the ire of John Smith's "Old

Ring" by blasting their political machinations at a public meeting, Joe and Rose opted to stay in Hull until the birth of their child.

They leased a squarish gray house at 201 Beach Avenue (the corner of C Street and Beach) and settled down to enjoy the coming summer of 1915, secure in the knowledge that their obstetrician, Dr. Frederick Goode, had also labeled Hull as his seasonal resort of choice.

Hank Searls wrote in The Lost Prince,

> *They were not bored. There was the clean breeze-cooled sand by day, and in the evenings there were always the great resort hotels a few blocks south... Nantasket in 1915 was a blend of Monte Carlo and Coney Island. In the paneled game rooms of the Atlantic House, where rooms were twenty dollars a day at a time when boat fare from New York to Boston was $2.50, dice rattled. The beach had the only liquor licenses from Boston to Provincetown.*
>
> *Joe Kennedy seldom gambled, except when he could dictate the odds; he almost never drank. But he and Rose listened to John McCormack and George M. Cohan in the magnificent wooden Pacific House Hotel, watched the parade of sweeping skirts and straw boaters drift past the wide front porch of the Villa Napoli. Joe, in plus fours, played the local courses.*

The day drew nearer, and finally around 10:00 a.m. on July 25, 1915, in an upstairs room at 201 Beach Avenue, Rose gave birth to the first of the soon-to-be-star-crossed Kennedy children.

In 1915, the year of the birth of Joseph P. Kennedy, one million summer visitors traveled to Hull by steamboat from Boston.

Fitzgerald, for the first time a grandfather, sprinted into the house from the beach, where he had been spending time with his son Fred, to see his grandson. Calling the Boston papers immediately, he laid out the boy's future. "Is he going into politics? Well...he is going to be President of the United States," Doris Kearns Goodwin recorded in The Fitzgeralds and the Kennedys.

Joe and Rose delayed naming the baby boy, eventually surprising the Boston press by not attaching the name of Rose's father to him, but instead naming him for his own father. He had the Fitzgerald face, but the Kennedy body and soul. "To all appearances, young Joe was a child gifted by the gods. He seemed to have come directly out of Ireland, strong and glowingly handsome with his dark-blue eyes and his sturdy frame, filled with vitality, health and energy," Goodwin wrote.

The Kennedys, now a family of three, remained in Hull for eight weeks more, christening Joseph Patrick Jr. at the recently finished St. Ann's Church a few blocks south, which had just been dedicated the day the child was born. In the early fall, they rumbled out of town in a new Model-T Ford to their Brookline home.

Joe Jr. shared a bond with his parents that the other children would never know. For as John, Rosemary, Kathleen and the rest were born, their father became more and more removed from the family, indulging in his work of building a fortune and spending long periods away from home. Junior spent his formative years with his mother and father together, as Senior signed on as an assistant manager at the nearby Fore River Shipyard.

By the mid-1920s, though, Joe Sr. did begin to fade into the background of the children's lives, and Joe Jr. took over the role of authority figure over his brothers and sisters. Repressing emotion to always at least appear strong in front of them, he let a little bit of his childhood slip away.

Around this time, Joe Jr. developed a rivalry with his brother John that would linger between them for the rest of Joe's life. Sometimes Joe would seem to win, sometimes John and sometimes they literally crashed into each other headfirst and both lost. On one occasion, they raced in opposite directions around a block on their bikes, and heading straight for each other on the final turn, neither boy would budge from his course. They collided at full speed, ending up in a tangled mass of spokes, arms, pedals, legs and handlebars. John would always challenge, and Joe would always stand his ground.

Joe attended the best schools, or at least the best in the eyes of his father: Devotion, Noble and Greenough and finally Choate in Wallingford, Connecticut. After being denied membership to the Cohasset Country Club despite his wealth and Harvard degree, Joe Sr. pulled the family to New York in disgust of the still-prevalent anti-Irish Massachusetts sentiment, firing one last salvo at the city of his youth: "Boston is no place to bring up Catholic children."

Junior earned the nickname "Rat Face" at Choate for his protruding Kennedy teeth, and rated as an average student until his sixteenth birthday, when he realized that he was in a race with his less-motivated but intellectually superior younger brother. He picked up his grades, and after leaving Wallingford set out for the University of London's School of Economics, where he studied under socialist professor Harold Laski. Although Joe Sr. had no use for socialism, he felt sure that the world of the future would be run by big government and not by big business, a notion solidified in his mind by the coming of the Great Depression.

Returning from England, where he had patiently accepted ribbing from Laski and others for his refusal to stand down from his outspoken goal of becoming the first Catholic president of the United States, Junior enrolled at his father's alma mater, Harvard, in the fall of 1934.

At Harvard many of the personality traits that would shape the rest of his short life hardened. His chivalry showed the night he charged into a car where a woman was being beaten and threw his body in the path of the blows, brazenly disobeying a rule set by the university for underclassmen to do whatever they could to keep their names out of the news. He became a leader, adopting an "I'm going to do this, you can come if you want" attitude. And he avoided serious relationships with women, shying away from society girls to run with strippers and showgirls, women that he could never marry, as the son of the now-ambassador to the court of St. James.

The competition with John continued, but took on a whole new dimension. The younger Kennedy, also enrolling at Harvard, shared his brother's taste in the

Joseph P. Kennedy Jr. was christened at the new St. Ann's Church at Waveland.

opposite sex. One night, Joe and friend Lem Billings spotted John at a club with a young woman, and had him paged. While John stepped away, Joe moved in and ended up walking the woman home. When he returned at three that morning, John stood in the hallway waiting for him, hands balled in fists. What happened thereafter, no one will ever know, as Jack ordered Billings away, closing the door behind him.

Billings felt strongly that Joe would be a true force in the world someday. According to Goodwin, "Harvard was simply a way station, for he already had his heart set on a political future and he was so closely tied to his father's ambitions for him that there was little room for anything else." After a year of sobering maturation in Europe, experiencing firsthand the crumbling of nations on the brink of World War II, including charging directly into the heart of the Spanish Civil War against a tidal wave of fleeing refugees, Joe returned to America to finish up his law degree. By now his personality "combined his mother's activism and his father's passion for victory into an ethic of conspicuous heroism whose evidences were broken bones and bandages," wrote Peter Collier and David Horowitz in The Kennedys: An American Drama.

Fiercely isolationist at heart, Joe Jr. helped form the Harvard Committee Against Military Intervention. He had seen the Nazi war machine up close, and felt that the United States would be best served by staying out of the war. But when armed conflict finally did seem inevitable, he dutifully registered for the draft, volunteering for the naval air cadet program at the Squantum Naval Air Facility in Quincy, Massachusetts, in May of 1941. He felt it his duty to stand up for his family's name, as John, with a history of medical problems, would apparently never qualify for military service, and Bobby, still a teenager, was too young.

Wanting desperately to be a leader of his own flight crew, he trained hard, but in the end ranked only as a mediocre airman. After two months at Squantum, he moved on to ten months' training at Jacksonville, Florida, graduating seventy-seventh out of eighty-eight pilots, but seen by his superiors as good officer material. After operational training at Banana River (today encompassed by the John F. Kennedy Space Center) he joined VP-203 in Puerto Rico to fly reconnaissance missions over the Atlantic in PBM Mariners. The unit moved to Norfolk, Virginia, after running the island out of fuel, and Joe became antsy for action. If he was going to be in on this war, he wanted to be a hero.

His chance came after his promotion to lieutenant, junior grade, in early 1943. He volunteered for the formation of VB-110, slated to fly B-24 Liberators (re-christened PB4Y-1s by the navy) as reconnaissance and submarine hunting planes out of England. While shuttling the planes from a San Diego factory to the East Coast, he heard the harrowing news that John was missing in action,

after having taken advantage of his father's political pull to get an assignment in the South Pacific on a PT boat. When the story broke of his heroism, Joe reacted with outward enthusiasm and inward heartbreak. John earned a Navy-Marine Medal for keeping his crew alive after having their boat rammed from beneath them, while Joe still had not seen combat. After listening to family friends toast the absent hero, Joe spent a night crying in the darkness of his room, the competition with his brother tearing him apart.

Once in England, Joe set out to outdo his brother, becoming increasingly reckless in his pursuit to take out a German U-boat or somehow else make his mark. He developed a forbidden relationship with Pat Wilson, whose artillery officer husband had been off in Libya for two years—safely falling in love with a woman he could never marry. Reaching the end of his tour, completing thirty-five missions, he volunteered for extra duty so as not to miss the planned D-Day invasion. Shortly after taking part in Operation Cork, clearing the waters off the Normandy beaches before the invasion, he heard of a top-secret mission and jumped at the chance to take part in it.

A week after the June 6 invasion of the German-held coast of France, the Nazis launched their first V-1 rockets, or flying bombs, over the English Channel, striking London on the night of June 13. Four hit that night, and seventy-three slammed into the city two nights later. Thousands of pounds of bombs had been thrown at the launch sites in the previous months and hundreds of pilots had been lost, to no avail.

The U.S. Army Air Corps, hoping to stop the barrage, developed plans for Operation Aphrodite, which consisted of loading planes to the hilt with bombs, getting them airborne and pointed in the right direction, taking them over by remote control from another plane aloft and ordering the pilot to bail out before the drone dove on its target. Briefed on the mission, Joe volunteered to pilot the navy's first attempt, code named Anvil.

Scheduled to fly on August 12, Joe watched as ground crewmen loaded the plane with 344 boxes, each holding 55 pounds of Torpex and six 113-pound demolition charges of TNT. He called Lorelle Hearst, the wife of friend William Randolph Hearst Jr., to send a message home, should he not survive the flight. "I'm about to go into my act. If I don't come back, tell my dad—despite our differences—that I love him very much."

He took off that afternoon, escorted by sixteen P-51 Mustang fighter planes, two B-17 Flying Fortresses, a P-38 Lightning and Colonel Elliot Roosevelt, the president's son, following behind in a Mosquito with a camera to catch Joe bailing out on film. At about 6:15 p.m. Joe gave the call sign "Spade Flush" to indicate that the remote control system had taken over. At 6:20, the plane tipped

into a slight left turn and exploded. It was the largest engineered explosion ever created by man until that point in history. No part of Joseph P. Kennedy Jr.'s body was ever found.

Posthumously, the navy awarded Joe the Navy Cross, an award rated just above the one his brother had received.

Joe Kennedy Sr. withdrew from public life and his family upon hearing the news. His dream of raising a son to be president had, he felt, died with Joe Jr. in the skies over Newdelight Wood that day. Soon, though, he refocused his energy on his next oldest, John, hoping he would resolve to carry out the mission of his older brother in his memory and become that first Catholic president of the United States. In 1960, he reached that goal.

Were it not for the unfortunate and still unexplained accident that August afternoon in 1944, Joseph P. Kennedy Jr. may very well have survived the war to come back home and forge that life in politics of which he had always dreamed, and his brother John may just have continued on with his ambition of being a writer, instead of foraying into the political realm. The house at 201 Beach Avenue could today have been regarded as a national shrine, the birthplace of a president, but instead it stands boarded up each winter, denied that possibility by one risky mission too many, one final reach for glory gone bad. Outside its walls, the waters of the Atlantic continue to relentlessly ebb and flow, producing the same swish that once sounded in the baby ears of young Joe Kennedy Jr.

The War on Crime

Any good politician knows that the most important thing that he or she can do in office is to make sure that first and foremost the people in the constituency in question have the basic necessities of life that a government is supposed to provide. In short, they have to make sure the trains run on time.

Boss Smith did not have to worry about the trains, as the New York, New Haven and Hartford Railroad (and Floretta Vining) had that well under control. And he did not have to focus on much else in the way of controllable public projects. He and his cronies ran the town like a machine, making sure that all of the parts were well oiled at town meeting so that the work of the town could go on smoothly for the rest of the year.

While all proceeded in neat order—the laying out of roads, the upgrading of sidewalks, etc.—Smith could instead turn his head to both the economic improvement of the town and the demons that came with such progressivism. As more money flowed into town, so too did more crime.

In 1900, John L. Mitchell served as the chief of the Hull Police Department and, as with many offices in town during the days of the Old Ring, a staff meeting looked like a Smith family reunion. Mitchell, Smith's brother-in-law, oversaw a force of officers Reynolds, Mitchell, Smith, Mitchell, Mitchell, Mitchell, Bacon, Mahar and Tremaine. That trend continued for years to come. At the time, the job of policeman in Hull was a seasonal one. As the beachfront was where the action was in summer, most of the patrolling activity took place from Atlantic Hill to Whitehead Avenue. Then, as now, the land beyond the latter point was reserved mostly for full-time residents and summer dwellers. The day-trippers from the city of Boston frequented the bars, restaurants and amusements of the Golden Mile, and rarely strayed north.

There was such a crowd at Peddock's Island in the summer, though, that the town appointed one man, Chester B. Hayden, as a special officer to protect and

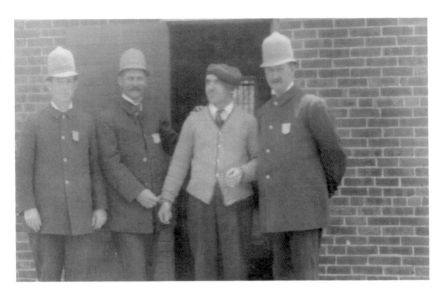

Crossing the Hull Police usually meant a night in the town lockup at the end of the nineteenth century.

serve the people who camped out on the island off the tip of Pemberton. Abner L. Leavitt kept the lockup for the town, and Edmund D. Studley took on fill-in duties as required. During the year, according to the Town of Hull's annual report for 1900, "six special officers were appointed for private individuals and corporations, to serve without pay from the town." Today these assignments would be called "details."

The year 1900 was a relatively quiet one, criminally speaking, for the people of Hull. By far the most popular crime was public drunkenness, with 91 arrests for it that year. Amazingly, with all those drunks stumbling around town, not to mention the many more coming out of the bars in the early morning hours who were not caught by Hull's finest, related crimes were very low. The Hull Police force in 1900 arrested 1 person for illegal liquor sales, 1 for assault, 4 for disturbing the peace and 1 for vagrancy, which may or may not have been alcohol related. In all, with four cases of larceny reported, only 102 people found themselves sitting under the watchful eye of Mr. Leavitt in the Hull lockup during the year. As the year-round population had doubled since 1890 to just more than one thousand residents, that meant that the population to arrest ratio was ten to one.

But things would get worse. 1901 was also a slow year, with even fewer arrests in town, a total of ninety-four. But the following year, crime was obviously on the rise. John L. Mitchell had left the police department to take over the fire department, leaving his assistant, Frank M. Reynolds, in charge of the force (now

Smith, Mitchell, Tremaine, Mitchell, Mahar, Mitchell, Bacon, Mitchell, Galiano, Goodman and Mitchell). A telltale note in the 1902 annual report hints that the residents of the town were beginning to feel uneasier about their once-protected little hamlet. "A numerously signed petition as well as several individual requests for the appointment of police officers for the winter months was received by the Board of Selectmen, who, after due consideration, appointed Jacob W. Smith and Louis F. Galiano to that duty." The year saw a growth in disturbing the peace arrests from four in 1900 to fifteen in 1901 to thirty-two in 1902. There had been two assaults in town, one with a dangerous weapon. One pickpocket had been arrested—a laughable statistic, if Doc Bergan's stories in Old Nantasket about the proliferation of pickpockets at Nantasket Beach are to be believed—as had one individual for breaking and entering.

In yet another revealing statistic, one person was arrested for fast driving. The car was coming to Hull, a place well known for availability of alcohol. The mixture then, as now, was not a good one.

Steamboats and trains brought more people to town. In 1915 the steamers would carry an estimated one million visitors to Hull for summer fun on the beach. With the mass manufacturing of automobiles on the rise and in 1905 the coming of Paragon Park, Hull's year-round population was suddenly and obviously dwarfed by the crowds. Yet still, Hull's police force remained small, a chief and a handful of regular officers.

Drunkenness skyrocketed, from 116 arrests in 1903 to a staggering 250 in 1908. Assaults jumped from 2 to 14. Disturbing the peace arrests climbed from none in 1903 to 18 in 1908, and even crimes against the public order were on the rise; 8 people were arrested for indecent exposure, while 5 had been arrested in total over the past seven years; 8 were arrested for using profane language, with only 8 others having been hauled in for the same crime from 1900 to 1907. Notably, the Hull Police made their only significant gambling raid of the first fifteen years of the new century, nabbing 24 people for "being present where gambling implements were found" and one for "keeping a place of gambling." In all, a record 348 arrests were made in Hull in 1908.

Chief Reynolds reported the trying year to the town through his report for the Annual Report of the Town of Hull for 1908:

> *In submitting my annual report I wish to say that in the past year this department has had to make more arrests than in any previous year. The number of accident and hospital cases, and cases where sick patients have had to be removed from here have been very large and this department is in need of a combination patrol wagon and ambulance,*

it hardly seems the proper thing for a Town as advanced as we are to be obliged to use an open express wagon to convey a woman or man who may have been injured to the boat or train, in order to send them to the hospital. One case this past summer we waited forty-five minutes to get an express wagon to move a man who was dying of injuries.

The statistics, though, should be looked at from two perspectives. First, the number of arrests might convey the notion that crime was on the rise. More people, more alcohol flowing and the ever-increasing national movement to the eight-hour workday combined to make Hull a melting pot for public indecency and disorder in one form or another. Second, however, the statistics may show a flash of power or zero tolerance for such behavior in town by the Hull Police. In fact, in 1909, 1910 and 1911, arrests dropped precipitously, to 295, 156 and 150, respectively.

Drunkenness remained the number one problem in town, yet with correspondingly lower numbers to the numbers of arrests in 1909, 1910 and 1911: 230, 126 and 116. Cases of disturbing the peace peaked in 1909 with 23, and did not rise above 7 cases in a single year between then and 1915. All other crimes on the books saw dramatic decreases through 1911, except for in one category: 2 arrests were made for "violation of automobile laws" in 1909, and 2 in 1910. That number tripled to 6 in 1911.

Fort Andrew — Paddock's Island, Boston Harbor.

Even though the island had a military presence, Peddocks was assigned a special policeman for the summer because of its high crime rate.

The War on Crime

Unfortunately for Chief Reynolds and his men, things were once again about to take a turn for the worse. The years 1912, 1913 and 1914 saw increases in total arrests from 205 to 251 to 349, a mark that beat the old 1908 record by one for the most arrests in a single year by the Hull Police. Drunkenness again ruled the streets as arrests climbed from 116 in 1911, to 166 in 1912, to 206 in 1913, to 289 in 1914. For the second time in two years, Hull cops arrested a person for attempted murder in 1912, and 6 arrests were made that year for assaulting a police officer. Three people were arrested for "disturbance on a steamboat" and larceny went from 3 cases in 1912 to 14 in 1914. While only 1 person was arrested for public indecency in 1912 and only 1 for profane language, 2 were arrested for public fornication. Since 1900, only 1 other person (inexplicably) had been arrested for the act. Automobile law violations grew from 6 in 1912 to 27 in 1914. In 1915, 52 arrests were made for such crimes. In 1913, 3 arrests were made for "operating an automobile while under the influence of alcohol," Hull's first documented drunk driving arrests. And the statistics show that crime among women, while still mainly under control, was becoming more of a factor: 1 woman was arrested by the Hull Police in 1911, 2 in 1912, 3 in 1913, 9 in 1914 and 10 in 1915.

In 1915, Chief Reynolds put out a second, urgent call for help from the board of selectmen.

Who knew what young men could get up to when camping on Peddocks, like this suspicious bunch?

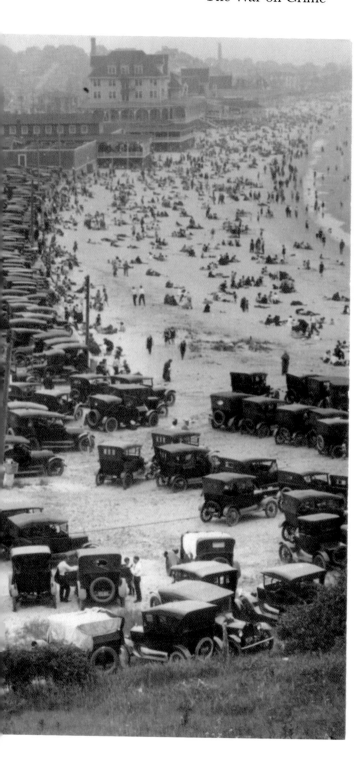

Increasing crowd sizes, increased consumption of alcohol and the rise of the automobile added up to stressful times for the Hull Police in the 1910s.

The Police Department is in need of a new police station, as the present one is not large enough to care for the prisoners, and the sanitary condition is very poor, and is liable to be condemned any day by the State Board of Health. The Department is in great need of an emergency room to care for accident cases, which have increased heavily in the last few years, and will continue to increase, as the business of the department has increased.

Boss Smith was listening, and could see that he was losing the war on crime in Hull. But he had much more important things to worry about in 1915, as by then his well-oiled machine was starting to show signs of breaking down.

The Great John L.

John L. Mitchell played the game like no one else. As Hull's chief of police in the late 1890s and early 1900s, he ruled Nantasket Beach like a czar, taking bribes from liquor purveyors and operators of houses of ill repute, all at the direction of the chairman of the board of selectmen, John Smith. The action at the beach became so blatant in 1897 that it prompted the Boston Traveler to publish two lengthy exposés of the political corruption in the district.

First, on August 21, the Traveler described just one of the unruly summer nights on the town's first golden mile.

> It was a wild and riotous time. There were frequent excursions over the plank walk to the Tivoli, some of them headed by Chief John Mitchell in person, and the bar, which was kept open until 3 o'clock in spite of the so-called police regulations, was generously patronized by Chief Mitchell and his men. Their feminine companions were served on the piazza and in the private room upstairs, and did a rushing business, I understand, until 4 o'clock this morning. All regular patrons of the hotel were barred out after 10 o'clock.

Another night's sleuthing brought more sordid tales.

> There are bathing parties after dark, from which the police studiously keep away, which disgrace civilization. On certain portions of the beach bathing suits are deemed unnecessary. On the more public portions, costumes more scanty than any newspaper dare picture, are an every night sight both among men and women. I don't know whether John Mitchell, Chief of Police, winks at all this, because he has to or because he wants to. Mitchell is a good fellow, a typical Yankee in appearance,

of genial whole-souled temperament, loyal to his friends, and generally speaking, a good all-round fellow. So is John Y. McKane.

McKane, formerly known as the King of Coney Island, was then doing prison time at Sing-Sing for his notorious dealings on that stretch of New York beachfront.

Following the publication of the article, Mitchell led a series of liquor raids on the local establishments, but many of the proprietors apparently received tips as to what would be happening and little liquor actually materialized. The Traveler called for Mitchell's resignation.

Yes, John L. Mitchell knew how far he could go with his dealings on Nantasket Beach. In fact, as far as Hull politics went in those days under the closed corporation of John Smith's Old Ring, no one was closer to the top, for John Mitchell had married John Smith's sister.

So what, then, could have caused the rift in the party in the 1910s that led to the freezing out of Mitchell, and only the second ever contested election in the first twenty-six years of John Smith's reign as boss?

All was well with the Old Ring in 1915. John Smith, as superintendent of streets, was reaping a fortune off the town's road building projects. The Town "voted" to build portions of sixteen different roadways that year at a cost of $17,000, on top of spending $12,000 for street repairs and paying the

Hull's fire department would eventually move its headquarters from Atlantic Hill to the corner of A Street and Nantasket Avenue.

superintendent an annual salary of $1,500. But his salary was not all the money Smith received from the town coffers that year.

The Town of Hull's 1915 annual report shows that Smith earned $50 for being on the fire engine committee, as the town purchased a new truck for then–Fire Chief John L. Mitchell; a total of $2,782.91 from the highway department, including $382.50 for storage of town tools; $100 for his services as selectman; $10 for being an overseer of the poor; $25 for serving amusement licenses; $10 as an election officer; $876 for a macadam project; $1,316.50 from the road building project; $225 in back pay for his services as selectman in 1914 and $300 more for his service in 1915; $50 in back pay for his service as an overseer of the poor in 1914; $52 for sidewalk repairs; $29.50 for snow removal; $25 for sitting on the house improvement committee; and $505 for service in oiling the streets. All told, that comes to $8,239.41 in checks that John Smith signed over to himself in 1915.

John Wheeler, the moneyman behind the Old Ring, who never took more than a token town appointment, did nearly as well in 1915. He collected $3 for loam for the cemetery; $29.25 for transporting Hull students to Hingham High School; $276.50 from the town health department; $728.33 from the highway department; $266 for providing autos and carriages; $89.25 from the Hull Public Library for loam, a team and sitting on the library committee; $305.77 for the same macadam project that lined Smith's pockets; $29.75 for the suppression of moths; $633.38 for the street project; $160.10 from the parks department; $1.50 from the police; $75 for sitting on the board of health; $2,600 for garbage collection; $1,685.75 for conveying children to school; $172.08 from the sewer department; $167.64 for snow removal; $16 for town hall and house alterations; $286 for oiling the streets; and $155.63 from the electric light department. His total came to $7,404.53.

John L. Mitchell's share of the winnings totaled $8,697.72. The major road building projects continued for the next few years, but the foundation on which they were sitting began to tremble.

The town was under an epidemic of fire at the start of 1916, and Mitchell, as fire chief, had his hands full. A late January conflagration caused some damage to Smith's Tavern (run by George Smith) on Atlantic Avenue, and a major blaze destroyed one of Hull's most prominent landmarks, the Rockland House hotel, on February 4. In the face of all the troubles, the Town voted at town meeting to increase the pay of the Hull firemen and to purchase a new chemical truck, but according to Arthur Hayward in the Hull Beacon, "Nothing was done in regard to increasing the drivers' salaries." John L. Mitchell was again appointed fire chief, and George Hatchard and Jacob W. Smith received appointments to

the Board of Fire Engineers. In April, Mitchell took his annual excursion to the sulphur baths of Hot Springs, Arkansas.

An independent spirit had bubbled before town meeting, though, as a petition circulating around Allerton Hill called for an automobile to drive Hull children to school rather than the old horse-drawn barge then being used. While Smith and Wheeler would have been happy to provide the town's first self-powered school bus at an inflated price, the petition called for the contract to carry the kids to school to go to the lowest bidder, an obstacle the Old Ring had never come up against before.

In the summer of 1916, John Smith moved into his new home on Atlantic Hill, while John Mitchell and his firemen chased false alarms all over town. The scene of the trucks flying through the streets became almost comical, but Mitchell didn't care, as he was at the top of the world. And at that point, the townsfolk backed him as well, if the words of the Hull Beacon of August 4, 1916, can be believed: "Chief Mitchell is proud of the new fire car, and the town is proud of Chief Mitchell. If the apparatus proves as good a fire fighter as the Chief, it will be all right." The following week Mitchell and his wife led the parade at the second annual Hull firefighters' dance at Paragon Park. Again, the Hull Beacon heaped praise on him. "The Hull firemen should feel proud of their chief who respects and honors them by marching with them on this occasion." More false alarms rang out the last week in August.

A Gondola on the Lake, Paragon Park, Nantasket Beach, Mass.

When John L. Mitchell was at the top of his game, leading parades at Paragon Park, the amusement grounds had a definitively ethnic flair to them, including real gondoliers transported from Venice to steer locals around a manmade lagoon.

The Great John L.

In early September, Paragon Park experienced the first of its many tragic fires, and Mitchell again collected accolades, this time, though, at the expense of a famous Boston politician. As thousands visited Hull to see the smoking ruins of the once-vibrant park, they read in the local newspaper on September 15, 1916, "In the morning paper of last Monday it read that ex-Mayor John F. Fitzgerald had helped the Hull firemen at the Park fire. Let it be known that the Hull firemen have fought fires previous to any help from the ex-mayor and they are not soliciting his help now in fighting them. Under Chief Mitchell they have a worthy leader." Fitzgerald, Lieutenant Governor Calvin Coolidge and ex-mayor James Michael Curley all summered in Hull in 1916.

As late as November of 1916, Mitchell still stood in good stead with the Citizens' Association, the front name for the Old Ring. In fact, Boss Smith saw to the appointment of Fred L. Mitchell as "Aid to the Chief," or his personal driver. In the state elections of that month, Hull recorded its largest turnout ever, with 314 votes cast. The town was becoming politically aware.

Then, in 1917, a strange series of events—perhaps connected, perhaps not—began to unfold. It all started well for Mitchell, as he and his wife Letitia fêted their daughter of the same name on her twenty-first birthday with a gathering at the town hall. The following week nomination papers circulated through the town for Clarence Vaughn Nickerson to run for delegate to the upcoming Constitutional Convention. Nickerson, a longstanding member of the Old Ring, had also recently been reappointed superintendent of schools, and was also at that time serving as principal. Apparently, John Mitchell did not sign the nomination papers.

Then, at 12:45 on Sunday, January 27, a fire broke out in the Strawberry Hill stable of George H. Hatchard, himself a fireman. As Chief John L. Mitchell lay resting in his Main Street home in the Village with the grippe, Fred Mitchell led the crew. The building was a total loss. Hatchard's insurance had run out before the first of the month and he hadn't renewed it. Someone knew exactly when to strike the match.

That same week rumors circulated around town that perhaps this was the year the town should adopt the Australian secret ballot system of voting. According to Massachusetts General Laws, Section 6, Chapter 41, a town may choose to elect its officers through a secret ballot on a day separate from town meeting. "Ever since the town was founded up until March 3, 1919, all the town officials were nominated from the floor and elected in the town meeting," wrote William M. Bergan in Old Nantasket. "It was just another article in the warrant. There was no such thing as an election day up to that time." Boss Smith decided what the slate of officers would be one month before the meeting every year, and sat back and watched things unfold, always keeping his mouth shut during the process.

The columnist for the Hull Beacon voiced her opinion on the secret ballot as well. "Both Hingham and Cohasset use it. Are the Hull citizens so illiterate that they cannot use it? What is the matter then?"

A coal shortage began to hurt the wallet of Mitchell, the town's largest supplier of coal and construction lumber, with extensive property on the bay side of A Street. Mitchell's coal and lumber company covered the entire A Street/Central Avenue/B Street/Bay Avenue (now Cadish Avenue) block, as well as a large parcel on Milford Street and a wharf next to the town pier. Most of the money he earned back from the town came from his contracts to heat the schools and other municipal buildings.

Town meeting day arrived and all, as usual, went according to John Smith's plans. The town voted against an appropriation for a new ladder truck for the fire department, and Boss Smith dodged the secret ballot for another year. A month later, Clarence V. Nickerson got his wish, as the town apparently

For those folks looking for something even more exotic, the mysteries of Japan unfolded before their eyes in the shadow of the Rockland House.

gave him 230 of the 243 votes cast for representative to the Constitutional Convention. Immediately, though, a petition for recount emerged. "We, the undersigned registered voters of Hull, represent that we have reason to believe that the returns of the Election Officers of said Hull of the votes cast at the Primary on April 3, 1917, for the nomination of candidates for election to the Constitutional Convention are erroneous in this respect, that Walter L. Bouve, Clarence Vaughn Nickerson and Allen P. Soule were credited with more and Walter Shuebruk with less votes than were actually cast for them." The results of the election and the recount showed a total of three votes for Shuebruk, yet twelve men had signed the petition, including, surprisingly, John and Fred Mitchell. In the eyes of Boss Smith, his brother-in-law had openly declared war on the Old Ring.

Still looking for that new truck for his department, John Mitchell got his wish.

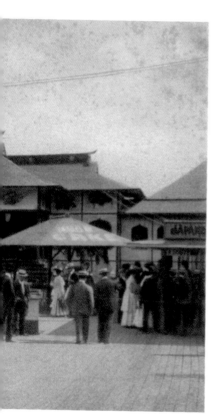

At a fire in Cohasset in early April, the station's old engine caught fire and was destroyed, and the town quickly voted $9,000 for the purchase of a new one on May 4.

Then, for Mitchell, the unthinkable happened. On Monday, August 6, a fire broke out on his Waveland coal wharf. The entire fire department rushed to the scene, although one truck being driven by George Collins from Green Hill crashed at Kenberma and never reached the scene of the blaze. The Hingham Fire Department and the naval reservists stationed at Bumpkin Island responded and helped keep the damage down. In the end, Mitchell lost $5,500 worth of property.

Rumors started to fly. The following week the Hull Beacon, referring to the country's current state of war, opined, "Let not the tongue of the corner orators, the stable crowds or the engine houses gatherers utter anything but true sincere American statements. Keep up the spirit at home by showing an American attitude. Put all the petty thoughts away." Fingers were being pointed. In the confusion of the day, an impostor moved through town soliciting funds for the Hull Fire Department.

John L. Mitchell regrouped by moving his wife and daughter to Brookline for the winter, spending most of his time there as well, distancing himself from the Old Ring.

Then, as November crept along, an opportunity arose. Alfred A. Galiano, a member of the board of selectmen and a trusted crony of Boss Smith, passed away on November 16, at the age of fifty-four years. The next town meeting would have to fill his seat. Mitchell announced his candidacy for selectman.

As 1918 commenced and Mitchell watched both his son Oscar march off to war in France and a trusted driver in Dick Walsh head for Florida to do the same task for the army, the excitement grew in the streets over the impending contest. "The coming March meeting promises to be a hummer," stated the Hull Beacon on February 1. "Ex-Chief of Police John L. Mitchell is a candidate for Selectman and Joseph Galiano is his opponent. 'Honest John' could certainly fill the position." Joseph was the brother of the late Alfred Galiano.

John Smith's worst fears finally came to pass at town meeting on March 4, 1918. A seat was being contested for the first time since 1893, and the Australian secret ballot had made its way onto the warrant. The crowd was so large that the meeting had to be moved to a nearby garage, as the town hall could not hold them all.

Doc Bergan wrote,

> *It was the wildest town meeting ever held in any Massachusetts community. The meeting got completely out of control, the police were helpless, chairs and tables were toppled over, a half dozen fist fights broke out, the moderator's table was knocked over and the town clerk's records were strewn all over the place.*
>
> *After the vote was all cast it began to quiet down. But when the tellers started to tabulate the votes, a mob gathered around them, and as the count was going on they demanded to see the yes and no vote slips and the confusion lasted more than two hours. After three recounts, the vote was finally announced: 162 in favor, 124 opposed.*

The Town of Hull finally had its secret ballot, but John Mitchell had lost to Joseph Galiano by a little more than thirty votes.

But Mitchell still held his position as fire chief, at least for the moment. When the board of selectmen refused to reappoint Mitchell's cohort George Hatchard as an engineer, Mitchell and the rest of his department had had enough. Also, according to the town report for 1918, the firemen never received payment for their services for the year 1917, as the Old Ring put the squeeze on Mitchell. On April 30, 1918, Mitchell and the entire fire department walked off the job.

The Great John L.

At midnight on May 1, Police Officer Henry J. Stevens—the new fire chief—and new fire engineers Raymond McDonald and Walden Smith reported to the station at A Street. According to their Report of the Board of Fire Engineers in the 1918 Hull Town Report, they "at once proceeded to examine apparatus, and found Engine Three out of repair, and Engine Four, the Webb, completely out of order and absolutely useless in every way. Neither of these machines could have been used at a fire, and the Chief's car was not left in condition to respond to an alarm."

On May 2, grass fires at H Street and Manomet Avenue and a false alarm at Box 13 pulled the new members of the department out in the damaged vehicles. Three days later another grass fire broke out on Samoset Avenue.

The report continued,

> As a result of false rumors maliciously circulated to injure the new administration and purposely brought to the attention of the Insurance Exchange to try to have insurance rates increased, the Insurance Exchange sent their Engineers here to inspect the Fire Department. They were highly displeased with many things. We were obliged to buy one thousand feet of hose at once at an expense of $900.00. They then proceeded to test the Engines, and, we regret to say, found not one that would come up to the requirements: Engine Four being in such a dismantled condition that it could not be tested at that time…
>
> The Chairman of that Committee said that, if the Department was to go back to the old administration, they would increase the rates 25 per cent, but that they were pleased to find after careful investigation, that the present personnel of the Department, in their opinion, is far superior to that previous to May 1st…
>
> We feel that a word should be said at this time in regard to the new fire whistle, contracted for under the old administration at an expense of over $2600, and which, up to the present time, we do not consider a very satisfactory expenditure. Also to the sum of $11,608.99 expended previous to our administration, leaving a balance for the remaining eight months of the year of only $5,472.01.

As the summer season arrived, the news of the war in Europe dominated both local newspapers, the Hull Beacon and the Hull East Wind. News that Arthur Irwin, a Hull boy, had been wounded arrived in March, but the news of the first death did not arrive until mid-September. Oscar Smith Mitchell, John and Letitia Mitchell's son, had died overseas. Even after all that had happened in town during the year, the Hull Beacon reported, "Mr. and Mrs. John L.

Mitchell and family have the sympathy of all in their late bereavement." To make matters worse, the Spanish flu raged through town in waves, infecting at least ninety-four people.

While political war raged at home, John Mitchell's son Oscar lost his life overseas in World War I, the first Hull soldier to do so.

John Mitchell, though, had resolve, and decided to keep fighting the Old Ring any way he could. With the secret ballot to be employed at the next town election in March of 1919, he figured his chances of winning a seat on the board of selectmen would be better than ever. A special town meeting held on November 29, 1918, packed the town hall in the Village, leaving several men standing in the wide stairwell, unable to fit on the floor above. Hull was as politically alive as it had ever been.

On January 28, 1919, the town had learned of the passing of Edward G. Knight in East Jaffrey, New Hampshire, after a brief illness. Born in 1840, Knight had served the town in several capacities over the course of his life, as selectman for twenty-seven years, town treasurer for fifteen years and in many other offices. A deacon of the Hull Methodist-Episcopalian Church, Knight had also formed Knight's Express livery service, later purchased by Warner Dailey and Newton Wanzer to become Dailey and Wanzer. A talented and prolific carpenter, Knight could have boasted to have built "nearly all the houses in Hull" if the Hull Beacon hadn't beaten him to it.

He spent most of his later years in the cause of temperance, a war waged in vain in Hull. In 1915, for instance, the Hull Police made 286 total arrests, 195 for drunkenness. (They also made 2 arrests for "stubbornness.") Things got so bad that Judge George Washington Kelley at Hingham District Court remonstrated the Hull Police for bringing so many drunks before him. John Smith knew that as long as liquor would sell on the streets of Hull, there would be a profit in it for him. It would take an act of Congress for Hull to give up its liquor licenses.

The passing of Knight meant the end of an era in Hull, as the old guard had moved on and could no longer look over the shoulder of the Old Ring.

As town meeting approached in 1919, the Hull Beacon threw its support behind the Old Ring. "The town election takes place Monday and there is little doubt that the candidates who have served the town so efficiently in the past will be reelected by a handsome majority." The Hull East Wind, though, supported the Independent Association candidates led by John L. Mitchell, possibly because of the large amount of advertising money they spent with that paper.

Mitchell and his friends posted contestants for almost all of the town offices. The ex-fire chief ran against Clarence V. Nickerson for selectman; C.F. Packard opposed the Old Ring's Henry H. Burr for school committee; George Hatchard, forced out as a fire engineer, ran against James Douglas and Charles West for assessor; and Freddie Mitchell challenged "Padlock" William Reddie for overseer of the poor. Nickerson also ran for town treasurer, unopposed. The town clerk, also a selectman, James Jeffrey, brought 600 regular ballots and 250 "ladies ballots" to the town hall.

When the ballots were counted, Burr had defeated Packard, 388 to 188, with 28 blanks; West, Douglas and Hatchard fell in line 297 to 269 to 160, with 156 blanks; Reddie defeated Fred Mitchell 235 to 174, with 32 blanks; Nickerson took the treasurer's seat 320 to 1 (a write-in for John O. Mitchell), with 120 blanks; and Nickerson also defeated John L. Mitchell for selectman, 246 to 184, with 11 blank ballots. Years later, Doc Bergan would reveal that the Old Ring had learned very quickly how to rig elections with secret ballots, yet no evidence exists to say that they rigged the contest of 1919.

The Hull Beacon, once a best friend to John L. Mitchell, turned its back on him. On March 7, 1919, the paper reported, "The result of the election Monday was expected and the Independent Association candidates who spent their campaign fund for a front page advt. in our esteemed contemporary were defeated. Evidently, the 'East Wind' had gone down."

A few weeks after the meeting, John L. Mitchell again visited Hot Springs for his annual sulphur baths. Within the year he would sell his coal and lumber facilities to the Waveland Improvement Association, and soon they fell under the control of the Hull and Nantasket Fuel Company, operated by the members of the Old Ring.

Mitchell had gone up against John Smith and lost the battle of a lifetime, but he had struck a significant blow against the Old Ring. John Smith wouldn't live forever, and his kingdom had to fall at some point. A young member of the Citizens' Association took all of these events in, keeping his mouth shut, practicing his dentistry and even trying a little semi-pro baseball in Maine, keeping his observances locked away for a future date. It wouldn't come until twenty years later in 1939, but after the death of Henry Stevens, who took over for Boss Smith upon his death in 1926, a rift between John Wheeler and Clarence Nickerson left the door open for William "Doc" Bergan to win a seat as selectman and break the back of John Smith's five-decade monster, the Old Ring.

A New Road into Town

The Old Ring had, by 1930, already dealt with several challenges to its authority. A major scandal in 1918 that ultimately involved the removal from power of Fire Chief John L. Mitchell and open fistfights at the old town hall over the advantages and disadvantages of the institution of the use of the Australian secret ballot in town elections led to a full midnight strike at the fire department on April 30, and the first seriously contested selectman's race since John Smith's Citizens' Association came to power in 1900.

Then, Boss Smith himself died on July 28, 1926. Seemingly, that event alone should have been enough to shake the foundation of the Old Ring, but as William M. "Doc" Bergan recounted in Old Nantasket, "The transition was so smooth that his political machine was just the same as if he was still there and ruling the roost."

Finally, in 1928, the new town boss, Henry J. Stevens, sensing discontent with the Old Ring's practices, allowed anybody who wanted to do so to walk out of a meeting and out of the "closed corporation" that was the Citizens' Association. Doc Bergan was one who turned his back on the group. For the next decade he fought to bring down the Old Ring, and they pulled every trick they knew to disgrace his name.

But in 1930, the year of the founding of the Hull Times, the Old Ring was still firmly in control of town politics and, more importantly to them, finances. The consolidated power remained in the hands of very few people. John R. Wheeler, known to be the moneyman who funded the activities of the political machine, served as chairman of the board of health, as a fence viewer and as a member of both the playground commission and the advisory board. He shared the latter with Charles S. McDowell, who was also chairman of the board of assessors, and Raymond McDonald, who also sat on the municipal light board, served as inspector of wires and was an engineer of the fire department.

Traffic concerns had the people of Hull thinking about a new way out of town in 1930.

The selectmen also multitasked, as it were. James Jeffrey held the position of tax collector for the town, while Henry Stevens also served as constable, fire chief and forest warden. Clarence Vaughn Nickerson, though, must have been the busiest man in Hull. Aside from chairing the board of selectmen, he served as town treasurer, tree warden, local superintendent of gypsy moths, superintendent of schools (one could reach him by asking the operator for Hull 0620), Hull Village School principal and a teacher of mathematics.

Stevens, in particular, would see his grip on the town tighten during 1930. At the annual election of March 3, the warrant asked, "Shall the Town vote to have its Selectmen appoint a Chief of Police and Fire Departments who may be designated as Commissioner of Public Safety?" For the most part, of the 846 voters who turned out that year, fewer than 100 voted against the Old Ring or left their ballots blank. But more than usual apparently saw the shortsightedness of combining the two positions into one. Although the question passed, the vote was 592 for, 187 against, with 65 blanks. Stevens accepted the new title bestowed upon him by his fellow selectmen proudly, bearing it until he died in September 1938, leaving the town without a police and fire chief just days before the Great Hurricane of 1938.

Five days later, town meeting voted through the regular slate of articles: $1,000 for cleaning Straits Pond; $14,000 to oil the streets; $73,500

for the schools, at that time just the Village and Damon primary schools (where, in 1930, a young Lillian Jacobs was teaching sixth grade); $36,000 for salaries for the police department; and $4,200 for the Hull Public Library and $400 for the Nantasket Branch of the Hull Public Library at West Corner. The town's ongoing dependence upon neighboring Hingham showed in its vote to appropriate $13,000 for transportation of Hull students to Hingham High School. Slowly, though, Hull was weaning itself off Hingham. The 1930 town report was the first not to be printed by the Hingham Journal for several years; instead, it was printed by the Hull Times.

The landscape of the town had been changing for several years. On March 28, 1923, Paragon Park burned for the second time, this time taking fifty houses with it. It rose from the ashes, of course, but with a new and updated look. The Atlantic House, once the most popular resort in town, sitting high atop the rocks overlooking the southernmost portion of Nantasket Beach, suspiciously burned down on January 1927. The five-masted schooner Nancy stranded on Nantasket Beach a month later, providing a sensational sight for summer beachgoers during the ensuing years. And on Thanksgiving Day 1929, while Doc Bergan was being arrested and publicly embarrassed by his former cronies in the Old Ring, the steamboats at the wharf at Nantasket caught fire, destroying five of the six summer steamers that brought the merchants of Nantasket Beach hundreds of thousands of patrons each season.

In 1930, the five-masted schooner Nancy sat high and dry on Nantasket Beach for all to see.

The steamboat fire, in particular, caused excessive hand-wringing at town hall (the new one of which was built in 1922 to accommodate Boss Smith's commuting needs; plans had called for a new building at the Kenberma playground, but that would have been too far for him to walk from Atlantic Hill). The Nantasket Steamboat Company had acted quickly to replace its lost fleet in time for the 1930 summer season, but had found that steamboat construction had changed in recent years. In short, the ships purchased had deeper drafts than the Weir River could accept. After approving $1,500 for a new dental clinic (one not headed up by Doc Bergan, and therefore placed squarely in competition with him) and before voting to purchase lots bounded by L and M Streets and Central Avenue for a future school building (eventually the Hull Memorial School), town meeting voted to put up $20,000 to match $60,000 in state money to dredge and otherwise improve the channel of the Weir River from Hingham Bay to the steamboat pier. The steamboats would get through.

Improvement in transportation access to the beach became the rallying cry for the rest of the year for the Old Ring. Regular roadway improvements continued at their steady pace, as Douglas Avenue on Gallops Hill, P Street, Fair Street and Brockton Circle were accepted and laid out. More ambitious projects awaited final approval, like plans for a Boston to Hull bridge that had been in the planning stages for most of the year, and the improvement of the inlet at Windermere, which called for the construction of a new barrier or gate. At that time, Nantasket Avenue was still the main method of egress for automobiles wishing to access homes on Stony Beach, in the Village and at Pemberton. The New York, New Haven and Hartford Railroad still owned the right of way now known as Fitzpatrick Way, and the land on which the Hull Yacht Club and Nantasket Saltwater Club now sit remained as sludge on the sea floor, about a decade from being dredged and used as fill.

The planned roadway to Boston would theoretically run from Columbia Circle in Boston across to Squantum in Quincy, then the home of a civilian airfield and a rudimentary naval air reserve training facility; over a 150-foot bridge to Peddocks Island; from Peddocks across Hull Gut and along Stony Beach; around Point Allerton and all the way down the coast to Atlantic Hill, elevated so as to allow for underpasses to the beach at the Nantasket Beach Reservation of the Metropolitan District Commission (so renamed from Metropolitan Park Commission in 1919). The "Ocean Drive" would then continue around Atlantic Hill, past Gun Rock Beach and head for Cohasset. The roads on the reservation, in fact, had become so poor that citizens had begun openly complaining to the MDC, the Boston newspapers and even to their state representatives for changes to be made.

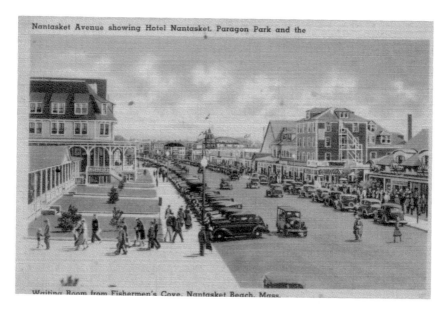

The town's plan for a road through the Weir River Estuary area would help relieve traffic congestion on Nantasket Avenue, and provide further competition for the steamboats.

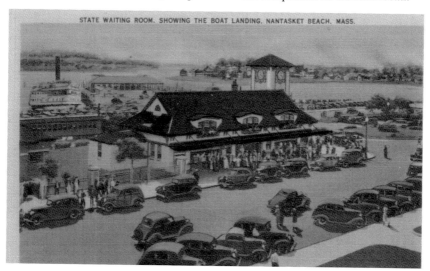

As usual, the Old Ring took matters into their own hands. At a special August town meeting, they asked the town to envision a major roadway that would ease the traffic at the beach, stretching from Bay Street and Anastos Corner to Rockland Street in Hingham atop Old Colony Hill.

Selectmen Nickerson, Jeffrey and Stevens wrote in the 1930 Report of the Financial Affairs of the Town of Hull,

> *For several years, a solution to the almost unbearable and dangerous traffic congestion problem at Nantasket has been sought. The Department of Public Works of the Commonwealth, the Metropolitan Planning Board and the Legislature have been appealed to, to assist. Various plans for traffic regulations and new roadways were proposed as being inadequate. In 1930, Mr. Walter B. Foster, the Town Engineer, made thorough surveys and presented a plan of a roadway from Bay Street at its junction with Nantasket Avenue to Rockland Street in Hingham. Believing that the construction of this road would solve the problem the Selectmen presented the plan to the Department of Public Works and petitioned the legislation if necessary. The Commissioners of Public Works visited the site of the proposed road and after many hearings and conferences agreed to include it in their budget for road construction provided that the Town of Hull would bear one third of the cost of construction and land damages. The Town then proceeded to appropriate in town meeting the sum of $150,000 as its share of the cost and further to expend no more than $175,000.*

The road to the new road was not that easily passable, though. The people of Hull celebrated Old Home Week and the Massachusetts Tercentenary from August 18 to 24, featuring historical pageants at the library and war memorial, outdoor concerts by the Hingham Community Band, a long-distance swimming championship race from Charlestown to Pemberton and yacht races off Waveland. "To those in the Town of Hull interested in restoring Yachting to Hull Bay," wrote the organizers of the festivities, "the sight of our Water dotted with sailing yachts, speed boats and small outboard motors must have been inspiring. We believe that the restoration of Yachting activities in our Bay will help bring back to Hull its old time prestige as a yachting center, which is in our minds one of the desired assets of a summer colony." A severe storm postponed the big finale, a parade and Gala Day, from August 23 to 31. All the while, a petition circulated throughout town to block the construction of the new state highway.

Students returned to the Damon and Village Schools in September. Those youngsters matriculating at the northern end of the peninsula returned to find that the town had leased Gould Hall, next to the Methodist church, for domestic science (personal hygiene and cooking) and music classes. Both schools underwent renovations during the year.

A New Road into Town

In early November, gunners at Rockaway returned for the annual duck hunting ritual that had taken place for centuries in and around the Weir River marshes. Company L of the Fifth Infantry arrived at Fort Revere to get the abandoned site back in inhabitable condition, as the government planned for its reoccupation. For the first time, the severity of the Great Depression began to show its effects, as unemployment became a serious, growing problem. The town moved quickly to put as many men as possible to work at the Hull Cemetery and at the Kenberma playground.

On Friday, November 14, the Supreme Judicial Court of the State of Massachusetts heard the debate over the proposed state road in Boston. "It looks as though the town of Hull will have neither a viaduct or a new state road from Nantasket," wrote the Hull Times in the November 20 edition. "By the time this 'political war' which now is raging ends, practically everyone will be owning aeroplanes." The war continued through the annual fall football contest between the Hull and Hingham town teams. Undefeated and as-yet-unscored-upon Hull fought to a tie with their archrival, 6-6, as Maurice Chevalier, Wallace Beery and Harold Lloyd films delighted crowds at the Bayside Theater that fall.

Finally, in December, the state road pot boiled over. The ongoing Prohibition experiment continued to grab headlines, as the Hull Police chased rumrunners hoping to offload their hooch at Kenberma, and Edwin Sheppard, proprietor of the Worrick Inn, received a suspended fine of $10,000 and a suspended two-year jail sentence for serving rum. Meanwhile, Representative John Q. Knowles pressured the state to fix the road surfaces at Nantasket. Then, at "one of the most sensational special meetings in the history of the town," according to the Hull Times, Clarence Nickerson debated resident Edwin Ulmer of Allerton, supposedly the generator of the opposition to the state highway project. "Nantasket Beach is a playground which cannot be enjoyed by the many thousands who wish to enjoy it with traffic conditions as they are at the present time. I prophesy that merchants, furthermore, will double, yes, quadruple their business if the new road goes thru. The simple A-B-C principle of traffic solution is to send traffic around and not thru the congested section." When put to the townspeople for a vote, they responded overwhelmingly in favor of the road's construction, 219 to 2, rescinding the August vote in order to reword it to indicate that Hull money should only be spent upon the Hull portion of the construction. Was this an accurate reflection of the town's will, or had the Old Ring, which had been fixing elections for years, even those conducted by secret ballot, pulled a classic fast one?

As the year closed, Town Counsel Joseph Conway outlined the town's transportation future, claiming the roadway would be constructed, the state

would clean up the reservation and the ocean drive from Boston to Cohasset would be built.

Of the three predictions, two came true. By the beginning of 1932, the state road from Bay Street to Rockland Street opened, bypassing the steamboat pier, Paragon Park and the grounded Mayflower steamboat—purchased by Doc Bergan and opened as a nightclub after the fire that nearly destroyed it—and cutting across the Weir River Estuary to Hingham. That year, the two hundredth anniversary of the birth of the Father of Our Country, the roadway bore its new name: George Washington Boulevard.

Cracks in the Wall

On Tuesday evening, September 15, 1938, the people of Hull lost arguably their most faithful and hardworking public servant in the town's history with the death of Selectman and Commissioner of Public Safety Henry John Stevens. The town fathers felt no hesitation whatsoever when they decided to eulogize him inside the pages of the 1938 Town Report with the same words Joshua James, a national hero, had been remembered by thirty-six years before: "Greater love hath no man than this—that a man lay down his life for his friends."

But the death of Stevens, a devout member of the Republican Citizens' Association, formed at the turn of the century by political boss John Smith, opened the doors to challengers of the Old Ring, who had not lost an election for any public seat for almost four decades. Over the next six months, a political war the likes of which this town had never seen before took shape, culminating in an election-day battle for the open selectman's seat between the Citizens' Association's Daniel J. Murphy and the perennial anti-administration candidate, Dr. William M. Bergan.

Born in 1887, Henry J. Stevens began his career in public service as a special summer officer for the Hull Police force in 1906. Two years later, at twenty-one years old, he joined the force full time. Six months later he left his beat on Green Hill to take an assignment at headquarters. In April of 1917, he became the first ever Hull motorcycle officer, instructed "to watch for speeding autoists," according to the Hull Beacon of April 27, 1917.

Around that time, his name first became synonymous with detective work when an investigation led by him brought the downfall and eventual conviction of a "notorious gang of hold-up men and auto thieves, who the police of several cities had long been seeking, and who had at that time selected the crowded community of Hull and Nantasket as their operations center," reported the Hull Town Report for 1938.

The death of Police Chief, Fire Chief and Chairman of the Board of Selectmen Henry J. Stevens, in front at the left, caused a rift in town government. William Armour, standing in the front row to his right, took over as police chief.

Stevens also gained fame for various daring rescues, pulling an incapacitated woman from sure death from the tracks in front of an approaching train

at Whitehead station and wading through waist-deep mud near the Nantasket steamboat pier to help a man and a woman who had become stuck struggle to safety. On shore, Stevens's fellow police officers gathered ropes and planks to complete the rescue. He would rise to become the town's first sergeant, and its first lieutenant.

On Tuesday night, April 29, 1918, Stevens's life took another amazing turn, for on that evening Fire Chief John L. Mitchell and his entire list of twenty-six firemen walked off the job over, essentially, the selectmen's choice not to reappoint George Hatchard as an engineer. On May 1 at 12:01 a.m., Stevens reported to the Central Fire Station as the town's new fire chief, along with his two new engineers, Raymond McDonald and Walden Smith.

Examining the fire apparatus, they found Engine Three "out of repair," Engine Four "completely out of order and absolutely useless in every way" and the chief's car "not left in condition to respond to an alarm." Moving quickly, Stevens organized the appointment of twenty-four firemen and the repair of the vehicles and other station equipment. On May 2 the new crew rushed to their first fire. Over the next eight months, with their chief doing double duty as a police officer, they responded to fifty more alarms.

As Stevens's reputation continued to grow, the by-now venerable town boss John Smith watched him with a fatherly eye. Pulling his young charge closely into the Old Ring, Smith groomed Stevens to be his successor as the town's unquestioned political leader. "He trained him in his method of operation so that when Smith died on July 28, 1926, and the baton was passed, the transition was so smooth, that [Smith's] political machine was just the same as if he was still there and ruling the roost. Stevens took up where Smith left off," wrote Bergan in Old Nantasket. In a special August election, Stevens added the title of selectman to his growing list of public positions.

In 1929, the town reelected Stevens as selectman, and at the following town meeting appointed him commissioner of public safety, combining the leadership of both the police and fire departments under one title. He would hold both positions until his death in 1938.

Yet Stevens, although beloved by many, still represented the political machine at its best. John Smith had learned the trade from the "Boston Mahatma," Martin Lomasney, a longtime political nemesis of former mayor and governor James Michael Curley, a summer resident of Hull. And what Smith learned he had passed on to Stevens. The Boston bosses, such as Lomasney, Curley and John "HoneyFitz" Fitzgerald, typified the successful politicians of the day; their methods may never have been clear, but they got results, and to many people that was all that mattered. They supported their own supporters, and undercut their enemies whenever given the chance.

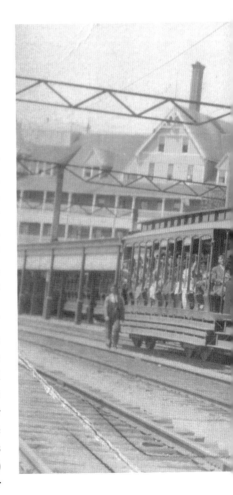

In 1937, when the men of the Point Allerton Coast Guard Station had been called to the Ohio River to help with flood duty, Stevens appeared at the station with twenty-five dollars for each man as emergency spending money. Nobody ever asked where the money came from. But in 1928, after "Doc" Bergan had parted company with the Old Ring, Stevens took the extra step to embarrass and publicly discredit him by sending the dentist's own brother John, a Hull police officer, to serve a summons on him for driving drunk. On a second occasion in 1929, Stevens paraded Bergan across a Hingham street handcuffed, for all to see.

Immediately following the death of Stevens on September 15, 1938, the town appointed Sergeant William H. Armour as chief of police and Deputy Chief Raymond McDonald as fire chief, later rescinding the act that created the position of commissioner of public safety. (On September 21, the Hurricane of 1938 hit Hull, a town that was at that time without a fire or police chief.) Andrew F. Pope, town clerk, and assessor

Charles S. McDowell announced their candidacies for the vacant selectman's seat right away, both hoping for the endorsement of the Citizens' Association. They would soon be joined by J. Elliot Mitchell of Natasco (now Vautrinot) Avenue, a bank executive in Boston. In early October, just before the special election, Doc Bergan announced he would run for Selectman Daniel J. Murphy's seat in March.

Before the Citizens' Association held their pre-election meeting, Pope withdrew his name from contention. The Old Ring then endorsed McDowell, causing Mitchell to resign from the association and announce he would run independently. His name never appeared on the ballot, though, due to his failure to file his nomination papers with the Board of Registrars in time. In an open

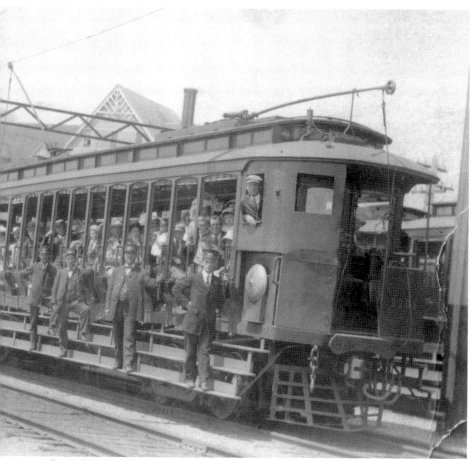

Just before the 1938 election, the old train lines that run the length of Hull were torn up. Streetcars, like this one at Pemberton, were a thing of the past.

letter to the townsfolk printed on the front page of the October 13, 1938 Hull Times, Mitchell explained his predicament. "My failure to comply with this most important detail was a great shock to me, as I expected that I would have a week in which to file papers after the Association Meeting. I now understand that the Association Meeting is always held the night before the deadline for filing, to obviate, I presume, any concentrated effort of any group who may be dissatisfied at the meeting from entering a candidate." Mitchell was forced to run on stickers, and lost by a healthy margin to McDowell.

Silently watching from afar, Doc Bergan spent his winter in preparation for the March election. Knowing that Stevens, who died relatively early at age fifty-one, had never trained a successor, the dentist wryly smiled as he heard rumors of dissent between Selectman Clarence Vaughn Nickerson and Chairman of the Board of Health John R. Wheeler, the town's only auto dealer and the chief financier of the Old Ring, who both tried to assume the powerful leadership of the Citizens' Association. For almost forty years, John Smith's political machine had been effortlessly churning out victorious candidates, never losing a single seat. Bergan knew that if the wounded feelings between Nickerson and Wheeler had a chance to heal, his opportunity would be gone.

Calling a couple of friends to join him, Bergan paid a visit to the one man who would know how to quickly exploit the rift: James Michael Curley. Curley instructed Bergan to do his best to fan the flames of dissension, and to focus his campaign on support of the workingman and his family. Bergan and his cohorts then scheduled a secret meeting with Wheeler, promising him that if elected, Doc and his followers would support the auto dealer as the new "boss." Wheeler and Bergan shook hands on the deal, the auto dealer promising the candidate a large block of votes.

Returning to Curley with the news, the former mayor and governor then decided Bergan should make a speech over a Boston radio station about the working-class families of Hull. After notifying all of the town's voters by mail that he would be speaking, Bergan's voice roared out over the airwaves on WEEI from 6:45 to 7:00p.m. on Friday, March 3, three days prior to the election. His speech, reprinted in full in Old Nantasket, shrewdly championed John Smith and Henry Stevens, and stated, "When there is no industry or other means of employment in a community, it then falls on the Government of that community to provide work for idle hands. There is no means of employment in Hull except for the influx of summer visitors and for the remaining nine months of the year our town, from an employment standpoint, is just a hell on earth." Despite the Depression, he reasoned that a healthy town treasury and streets full of unemployed citizens added up to political insensitivity, and possibly graft.

One man, William G. Eaton, responded to Bergan's mailing in time to take out a front-page Hull Times ad on March 2, 1939, the day before the speech. A thirty-year friend of Selectman Murphy, who had chosen to personally visit all of the voters at their homes in his bid for reelection, Eaton claimed his candidate

> *does not have to continually harp on the trial and vicissitudes of the "working man" and his family, or how by spending about $90,000 of the taxpayers' money, the town may be turned into a modern Utopia… Do you not think it would be better to re-elect a Selectman of tact, efficiency, and business ability than be carried away by gush, bombast and promises impossible to fill? Do you believe Mr. Murphy would so underestimate the intelligence of the working men of the town as to say "Put the men to work" without providing answers to the questions HOW and WHERE?…The question to be decided by you, Mr. and Mrs. Voter, is "Am I as dumb as one of the candidates thinks I am."*

The Times averaged the votes of Bergan's multiple losses: his 1931 school board loss to Peter McCormick; 1932 and '33 town moderator race losses

When he needed votes, Doc Bergan visited the Old Ring's moneyman, John Wheeler, who owned a Studebaker dealership at the corner of Nantasket Avenue and Spring Street.

to Herbert C. Huntress; and his 1937 board of assessors loss to Charles S. McDowell at 501. Given Daniel Murphy's victorious selectman election and reelection at 747, the paper predicted Murphy as a 7–5 favorite for Monday's election. Editor Herb Gordon fully expected a record turnout at the polls, estimating that the 1,600-plus registered Hull voters would easily shatter the 1932 record of 1,348 votes cast.

Heavy rain on Monday morning, though, dampened the spirits of a number of voters, and the total fell two shy of the record, at 1,346. But Editor Gordon had been right, as the selectman's race had been decided by a 741 to 591 margin, although he had it in reverse. For the first time in its existence, the Old Ring had lost an election, as Doc Bergan took the day.

The voice of the people came through loud and clear that day. Twenty-five-year-old Edward J. Haley, so young he and his eight siblings had just gotten over the mumps together, won a seat on the board of assessors, running independently against both Claremont F. Packard and Harland Skelton of the Citizens' Association. The Old Ring's castle had not yet crumbled, but thanks to Bergan, Haley and James Michael Curley, its walls had been breached.

One Man's Memories of Hull

One can spend days, weeks, months—heck, a lifetime—searching for the next great tidbit of Hull history. There are dusty antiquarian bookshops, creaky rolls of ancient newspapers on microfilm, musty old ledgers and diaries and, for the computer literate, Google searches. Sometimes, though, simple memory is the best conduit of information for the Hull historian, shared through conversation or even a letter sent through the post office. Remember those? With e-mail now the king of interpersonal communication, it seems the good old-fashioned handwritten correspondence should now be classified as an endangered species.

That's where Herb Skellett of Quincy, formerly of Hull, comes in. The Hull Times received a letter from him recently, addressed to this writer, a reminiscence of the old days in town. To the local historian, messages like this one are as valuable as any nugget found in a water-damaged copy of the old Hull Beacon or a fading town report from the 1920s.

"Dear Sir," the letter begins. "I am a subscriber to the Hull Times and read your interesting articles. I lived in Hull many years, from 1928 to 1990. My father purchased a home in 1928 from Henry Stevens on Whitehead Avenue for $3000 (a 7-room house). Mr. Stevens was chief of police, chief of the fire department and owned the fuel company. He and John Wheeler were partners."

To say that Stevens and Wheeler were merely partners is a decided understatement. No two names are more synonymous with Hull's Old Ring political machine than Stevens and Wheeler, save for maybe John "Boss" Smith and Clarence Vaughn Nickerson. By the time young Herb moved to town in 1928, Stevens, who was also Hull's first motorcycle cop, had taken one more position in town, that of chairman of the board of selectmen, upon the death of Boss Smith in 1927. When he became chief of police in 1930 (he had been chief of the fire department since a defiant anti–Old Ring walkout by John L.

Mitchell and crew in 1918), he took the title of commissioner of public safety, meaning that all the power rested with him. His countenance is displayed today on a bronze plaque on the façade of the Central Fire Station at A Street.

John Wheeler was more of the quiet type, opting to work from the shadows. The acknowledged moneyman of the Old Ring, Wheeler operated a Studebaker dealership on the corner of Nantasket Avenue and Spring Street in Hull Village, taking no more than the odd board of health appointment. By the 1920s, he was a three-decade veteran of the Hull political wars, and had made thousands of dollars off municipal contracts. When, in 1938, Stevens died and the members of the Old Ring were wrestling for control of the town, Wheeler supported William M. "Doc" Bergan for selectman over Nickerson, promising him a block of votes for the right to run things from behind the scenes.

"My father originated the Boy Scouts about 1930," continues Skellett. "Jim McLearn was assistant scoutmaster." The M*A*S*H character Hawkeye Pierce once summed up the typical American childhood of the 1930s and '40s by saying, "You knew where you stood in those days. Franklin Roosevelt was always President, Joe Louis was always the champ, and Paul Muni played everybody in the movies." There was a consistency to small-town life that we do not have today, as the average American citizen has become much more mobile, much more prone to chase the American dream from town to town. Fixtures in local politics were in place seemingly forever, teachers never switched jobs and youth sport coaches watched generations of children move through their programs.

Skellett continues,

> *My father came to Nantasket to start the Gas Company—Old Colony Gas from Braintree. My father ran fights at the Ocean Gardens which is now the Clarion. He also trained Ernie Minelli, John Gillis, Frank Mercurio and many more boxers who became New England champs.*
>
> *In those days we had 3 theaters, Apollo, Bayside and one at Kenberma. I got my social security card in 1937 being an usher at the Bayside Theater. Dan Murphy ran the Bayside and Loring Hall in Hingham.*

In the 1930s, movies—just recently converted from silent films to "talkies"—moved in and out of theaters in a week. The Hull Times featured front-page ads from all of the competing movie halls, luring folks to see John Garfield, Great Garbo, Douglas Fairbanks Jr. or a fading Clara Bow (she had "It" until audiences heard what she really sounded like) on the big screen. Today, the Loring Hall is all that remains of those days of the golden age of Hollywood.

"We had two bowling alleys, Ocean Gardens and where the condos are at the beginning of the beach," Skellett remembers. "There was also a Howard Johnson's there." The bowling alleys of Ocean Gardens became known to later generations as Webster Shore Lanes, still playable in the early 1980s. In earlier days, when bowling fever first struck the people of Hull, lanes could be found in the "East End" of Hull Village and even in the old Hull Yacht Club. And more than just Howard Johnson's could be seen in Hull. From time to time the ice cream mogul himself raced his powerboats off Hull in the 1930s.

"We had many Jewish delicatessens, Haglers and Minevitz plus Dan's and the A Street Deli," Skellett adds. Who remembers "Dirty Dan's" in the Hull Redevelopment Authority land before its removal in the 1970s? "Doc Bergan was my dentist and he always wrote to me when I was overseas during World War II." Doc Bergan's home and dental office was the lone large building saved from the wrecking ball during the urban renewal project that took Dirty Dan's and all the others. It was good to have political pull when the bulldozers came crashing through.

"The Nancy washed ashore at the beach behind Doc Bergan's." The Nancy had been on the beach for a year by the time the Skelletts came to town, stranding on February 19, 1927, during a snowstorm, and it stayed for more than a decade. There wasn't a child alive in the early 1930s in Hull who could forget its presence. "I used to play on this ship when we were young." Mr. Skellett's letter included a blown-up photo of the ship. "One of the kids named Biladeau broke his leg and that scared us off. Grossman [of Grossmans's lumber yard in Braintree] bought it and took it apart for lumber, I guess. They say part of the keel may still be under the sand." A Works Progress Administration workforce burned what remained of the boat down to its keel in the late 1930s, burying what remained thereafter.

And then, of course, there were the schools. "Lillian Jacobs was my teacher in the Damon School in the fifth grade," he reminisces, proving to all current Hull elementary schoolers that Ms. Jacobs was a real person and not just a name on a wall. "There was no high school in Hull so we went to the eighth grade to school on Spring Street, then we bussed to Hingham." That system held in place until the first graduating class left Hull High School in 1958, just a half-century ago. The old Village School stood next to the old Hull Methodist Church, now just a vacant lot covered with the refuse of the recent Main Street roadway expansion project in Hull Village. All that remains is the ancient clock tower, now atop the Hull Memorial School. The Hull Historical Society has saved one other artifact from that school—a tiny desk.

The most wonderful aspect about letters like the one recently sent by Mr. Skellett is that they leave the local historian with more questions than answers,

and anticipation to sit down with the writer and find out more. Where did he serve in World War II? What more can be said about Lillian Jacobs, Henry Stevens and Doc Bergan? Are there any memories of the old hotels? The Hurricane of 1938? The Coast Guard? Fort Revere?

Among Herb Skellett's memories are scenes of the five-masted schooner Nancy on Nantasket Beach.

Hopefully, more Hull residents will take the time to write their thoughts down, as every memory is another important bit of Hull history.

"My name is on the World War II Memorial statue at Whitehead," Skellett ends his letter, followed by a PS: "Hope you can read this."

We read you loud and clear, Mr. Skellett.

Visit us at
www.historypress.net